MICHELANGELO
The British Museum

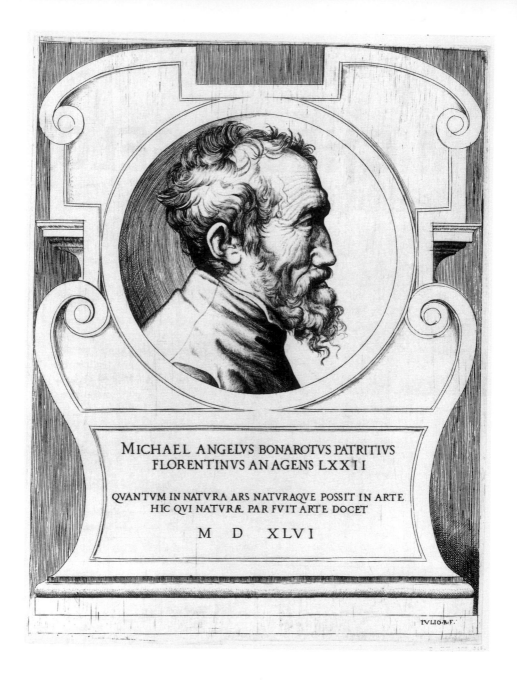

MICHAEL ANGELVS BONAROTVS PATRITIVS
FLORENTINVS AN AGENS LXXII

QVANTVM IN NATVRA ARS NATVRAQVE POSSIT IN ARTE
HIC QVI NATVRÆ PAR FVIT ARTE DOCET

M D XLVI

TVLIO·B·F.

MICHELANGELO
The British Museum

Hugo Chapman

THE BRITISH MUSEUM PRESS

Hugo Chapman has asserted the right to be identified as the author of this work

First published in 2006 by The British Museum Press
A division of The British Museum Company Ltd
38 Russell Square, London WC1B 3QQ
www.britishmuseum.co.uk

Reprinted (twice) 2006

A catalogue record for this book is available from the British Library

ISBN-13: 978-0-7141-2462-9

ISBN-10: 0-7141-2462-1

Designed by Tim Harvey
Printed in Spain by Grafos SA, Barcelona

frontispiece
Giulio Bonasone (*c.* 1510–1576),
Portrait of Michelangelo, 1546.
Engraving, 23.8 × 17.6 cm.

Michelangelo: Significant Dates

1475	6 March. Born in Caprese near Arezzo
1487	Documented in the Ghirlandaio workshop in Florence
c. 1488/92	Joins household of Lorenzo de'Medici and studies in the Medici Garden
1494	French invasion of Italy. Expulsion of Piero de'Medici from Florence and establishment of first Florentine Republic. Michelangelo works in Bologna
1496	Arrives in Rome, aged twenty-one; commission for the *Bacchus* sculpture
1498	Contract for the marble *Pietà*
1501	Returns to Florence. Contract for the marble *David* (installed outside Palazzo Vecchio in 1504)
1503	Contract to carve twelve over-life size *Apostles* for Florence cathedral
1504	Begins work on the *Battle of Cascina* cartoon. At work on the *Bruges Madonna*, and the *Taddei* and *Pitti* marble tondos. *Doni Tondo* panel painting probably completed
1505	Summoned to Rome by Pope Julius II and commissioned to execute his tomb
1506	Returns to Florence. Works in Bologna on a monumental bronze statue of Julius II (destroyed 1511)
1508	Commission for Sistine chapel in Vatican (finished in late summer 1512)
1513	New contract for the Julius tomb for which Michelangelo begins sculpting the *Dying* and *Awakening Slaves*, and the *Moses*

1516	Michelangelo, aged forty-one, returns to Florence to design façade for S. Lorenzo
1520	Façade project abandoned, replaced by the Medici chapel project in S. Lorenzo
1524	Intensive work in the Medici chapel begins. Commission to build the Laurentian library
1528/9	Michelangelo oversees the fortifications of Florence
1532	August. A long visit to Rome and the beginning of his friendship with Tommaso de'Cavalieri
1533	Returns to Florence. Commissioned to paint the *Last Judgement* on the Sistine chapel altar wall
1534	Permanently abandons Florence, leaving the Medici chapel and the Laurentian library unfinished
1536	November. Begins the fresco of the *Last Judgement* (completed October 1541)
1536/8	Friendship with Vittoria Colonna begins
1542	Begins the two frescoes in the Pauline chapel (completed 1550)
1545	Completion of the Julius II tomb in S. Pietro in Vincoli, Rome
1546	Takes over the construction of St Peter's and Palazzo Farnese
1552/3	Begins his last sculpture, the *Rondanini Pietà*
1561	Contract for the Porta Pia
1564	18 February. Michelangelo dies aged eighty-eight. Body taken to Florence and buried in S. Croce

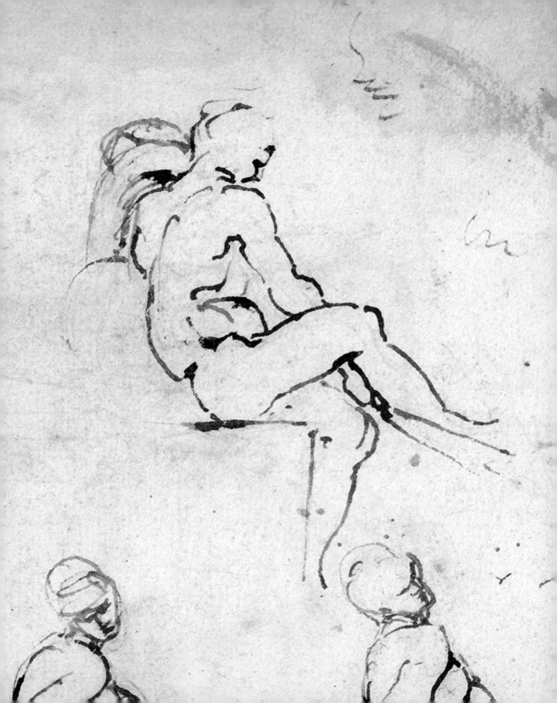

Michelangelo Buonarroti (1475–1564)

Michelangelo Buonarroti was one of the dominant figures of the Italian Renaissance, a period of cultural renewal inspired by classical models that reached its apogee during his lifetime. Celebrated as the greatest practitioner of sculpture, painting and architecture, he was also distinguished as a poet. For more than five decades, until his death in 1564 at the age of eighty-eight, Michelangelo remained at the centre of the competitive artistic world in the papal city of Rome. Underlying and uniting his achievements in all fields were his extraordinary gifts as a draughtsman and designer. His 600 or so surviving drawings clearly represent only a fraction of his total output, yet they still provide a unique window onto his creative processes.

The majority of Michelangelo's surviving drawings are preparatory studies intended solely for his own practical use. Nonetheless, they include some of his most inspiring and beautiful creations. His skill as a draughtsman can be seen in his exceptional ability to suggest the volume and motion of a figure by minutely changing the thickness and direction of a contour. This is exemplified by his rendition of the taut musculature of the nudes in fig. 11 (see also detail 1). His delicate touch was informed by his profound anatomical expertise, which was focused on the articulation of the skeleton and muscles, as well as by intense powers of observation developed through years of drawing from life. These qualities enabled him to exaggerate certain details of a pose without making the overall effect look unnatural, as can be seen from the rarely remarked upon impossibility of Adam's pose in fig. 14. Drawing was also an essential tool with which Michelangelo explored and developed ideas formed within his imagination, such as those relating to the Medici chapel tombs (figs 21–3) or his animated vision of the Crucifixion (fig. 35). In these works there is a palpable sense of how Michelangelo's creativity was spurred on by the process of drawing – the flow of his ideas quickening as he realized them on paper.

Detail 1 (from fig. 11)
Pen and brown ink, *c.* 1508.

Michelangelo's secretive nature made him jealously protective of his drawings, fearing that his inventions would be utilized by others, and after his death the bulk of them remained in his family's possession. In the nineteenth century some of this historic store of drawings was dispersed and the British Museum acquired around ninety sheets from the Buonarroti family and other sources. These range in date from around 1500, when Michelangelo was in his mid-twenties, to his last years, when he worked with faltering vision and tremulous control of the chalk on the two *Crucifixion* studies (figs 57–8; see also detail 2).

The male nude was Michelangelo's favoured vehicle of artistic expression throughout his life, and this single-mindedness is reflected in his graphic output. The languid motion of Adam, stretching upwards towards God on the Sistine chapel ceiling, is a celebrated example of Michelangelo's talent for finding a pose that captures the essence of a narrative. His success in addressing profound philosophical and theological issues through the movement and torsion of his figures flowed from the subtle calibrations made to their poses whilst drawing. It was perhaps Michelangelo's wish to obscure the effort that underpinned his art that led him to destroy numerous drawings before his death.

Michelangelo was born in 1475, the second of five sons, into an impoverished middle-class Florentine family. His background made his choice of career unexpected and, according to two contemporary biographies, his father initially opposed it. Nonetheless in 1487, at the age of twelve, Michelangelo is recorded as working as a painter's apprentice in the studio of the brothers Domenico and Davide Ghirlandaio. He probably remained there for about two years, and during this time would have learnt how to draw with a quill pen and with chalk. The activities of the productive Ghirlandaio workshop centred on Domenico's skills as a designer: Michelangelo would have witnessed how his master developed compositional ideas in preliminary sketches before making detailed studies of individual figures, once an overall design had been

Detail 2 (from fig. 58)
Black chalk, lead white, *c.* 1555–64.

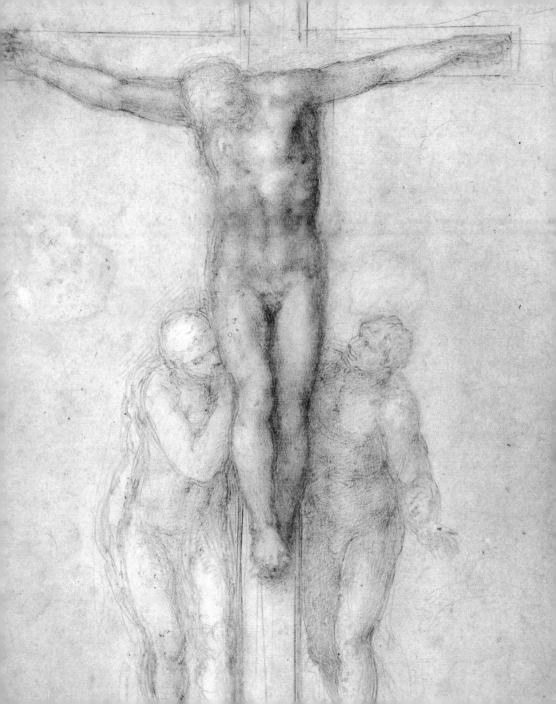

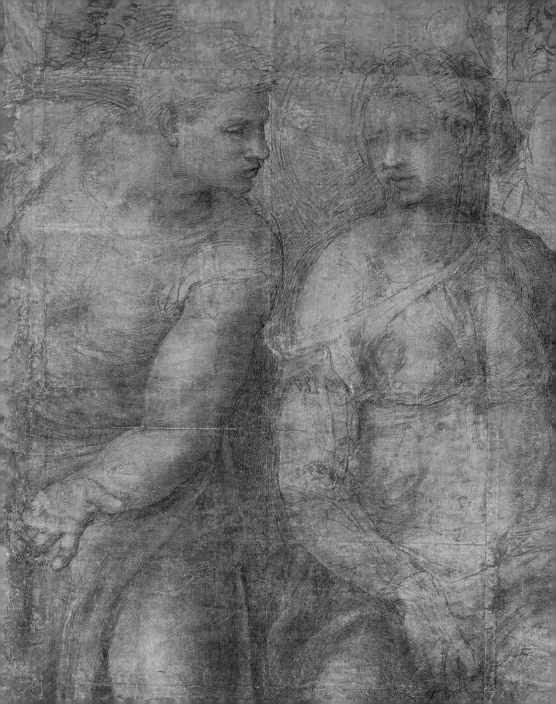

finalized. For large-scale works such as frescoes, full-sized drawings or 'cartoons' (derived from the Italian word *cartone* for a large sheet of paper) were made for the principal figures. The outlines of these were pressed or pricked through to the surface to be painted as a guide. Michelangelo used cartoons for his paintings, but only two survive. One of them was drawn in the 1550s to help his pupil and biographer, Ascanio Condivi (fig. 56; see also detail 3). In later life Michelangelo claimed that he was self-taught, but his time in Ghirlandaio's workshop had been significant, not least for his development as a draughtsman. Indeed throughout his career he remained true to his master's schooling in the Florentine *disegno* tradition, the Italian word encompassing both the mental formulation of the design as well as the resulting drawing.

Michelangelo's ambition to broaden his artistic education inspired him to give up his apprenticeship in order to attend an informal academy in the Medici Garden established by Lorenzo de'Medici (Lorenzo the Magnificent), the head of Florence's ruling family. Inspired by the works on view there Michelangelo began to sculpt in marble. His precocious talent was recognized by Lorenzo who invited him to join his household. As well as a statesman, Michelangelo's patron was a poet and humanist who attracted a dazzling circle of writers and scholars to his entourage. The young artist's intellectual horizons must have been significantly enlarged by his period in the Medici palace, which continued even after Lorenzo's death in 1492. He was also brought into contact with two of his future papal patrons: Leo X and Clement VII, respectively Lorenzo's son and nephew. During this time Michelangelo carved his earliest marbles, the *Madonna of the Stairs* and the *Battle of the Centaurs* (both in the Casa Buonarroti in Florence). He also served Lorenzo's eldest son, Piero, whose injudicious opposition to the French invasion of Italy in 1494 resulted in the expulsion of the Medici from Florence and the establishment of the first Florentine Republic.

Michelangelo missed this change of government since he had already fled to northern Italy. He worked in Bologna, carving three small marble figures for the

Detail 3 (from fig. 56)
Black chalk, 1550s.

tomb of St Dominic in the church of San Domenico. In 1495 he returned home, where he sculpted a now lost marble, *Sleeping Cupid*. This was successfully passed off as a classical piece and sold to Cardinal Riario in Rome. On learning the true history of the work, Riario invited Michelangelo to come to Rome in June 1496 and commissioned a marble statue of *Bacchus* (Museo Nazionale del Bargello, Florence). The cardinal rejected the finished work, perhaps because Michelangelo's characterization of the god as a drunken swaying figure was too far removed from classical models. The following summer Michelangelo was asked by a French cardinal to carve a life-size marble *Pietà* (the Virgin mourning the dead Christ) for his burial chapel in S. Petronilla, a church at the south side of old St Peter's (the marble is now housed in the new basilica). The originality of Michelangelo's concept and his virtuoso carving of the piece marked his coming of age as a sculptor. It is his only signed work.

At around the same time Michelangelo made a pen study in two shades of ink of a heavily draped, pensive old man (fig. 1; see also detail 4). His identity and the object held in his hands remain a mystery, although the cockleshell in his hat denotes that he is a pilgrim. The figure's imposing presence is established by the combination of extensive crosshatching with untouched areas of paper serving for the highlights. Some eight years later, around the time of the Sistine chapel commission, Michelangelo drew a male head on the verso using a mixture of pen and chalk (fig. 2). The sheet is an example of Michelangelo's well-documented parsimony, as he clearly went through his stock of drawings to find a sheet with a blank side.

Michelangelo returned to Florence in the spring of 1501, attracted by the revival of a project to sculpt for Florence cathedral a figure of David from a gigantic, partly worked block of marble. He duly won the contract in August and succeeded in meeting the demanding two-year deadline. Such was the impact of the *David*, the first colossal marble to be carved in Europe since ancient times, that it was decided to place it outside the Florentine seat of government, the Palazzo Vecchio, rather than

Detail 4 (from fig. 1)
Pen and brown ink, *c.* 1495–1500.

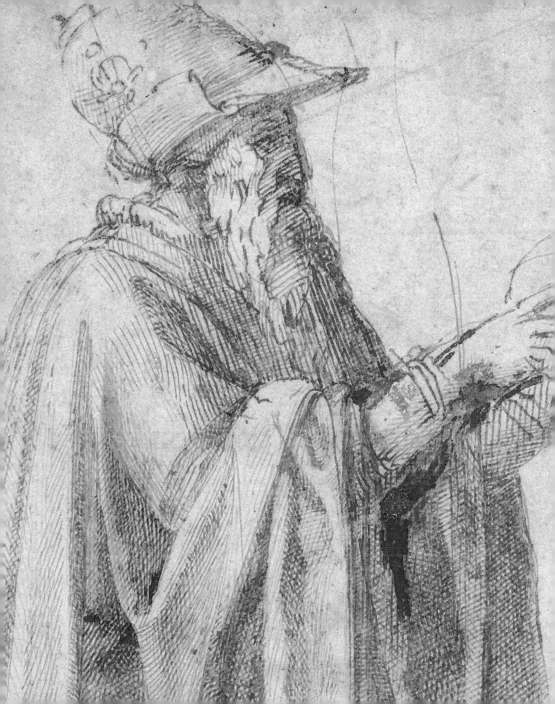

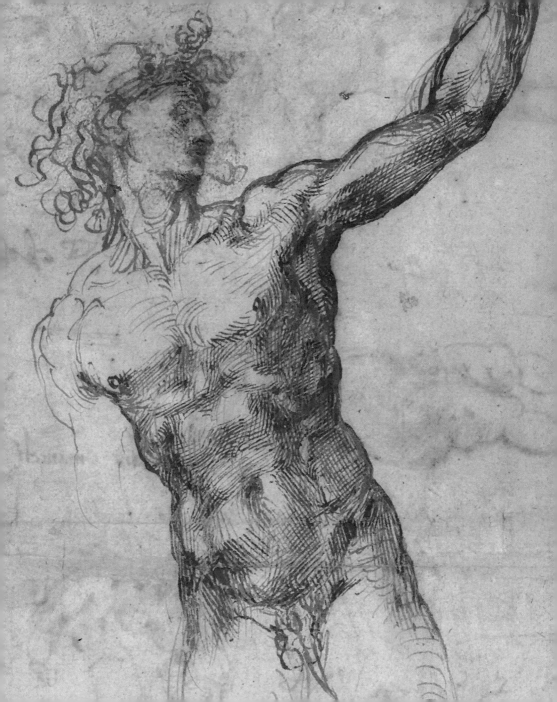

on a buttress of the cathedral. Florence's new leader, Piero Soderini, probably insti-
gated this change, as he was keen to use the city's most famous artists to promote
the Republic's precarious survival.

Soderini's greatest coup was to commission Leonardo da Vinci and Michelangelo
to paint two gigantic murals glorifying Florentine feats of arms in the Hall of the Great
Council in the Palazzo Vecchio. Michelangelo's *Battle of Cascina* celebrated a victory of
1364 over the Pisans. This was a topical subject as Florence had since 1494 been
unsuccessfully trying to recapture the port city. Unfortunately, the exhilarating prospect
of the two greatest Florentine artists of their respective generations vying with each
other ended in failure, as neither completed his work. Michelangelo's contribution ran
only to a now lost cartoon for the central section, a work known as the *Bathers*
because it depicted Florentine soldiers hurriedly preparing themselves for battle after a
dip in a river. This caused a sensation, because the explosive movement and dramatic
animation of Michelangelo's over-life-size figures was unlike anything that had come
before it. Some notion of the enthralling blend of naturalism and classical idealization
that informed Michelangelo's nudes can be gained through his life study for one of the
soldiers in pen and wash with white heightening (fig. 3). The impact of ancient Roman
sculpture on Michelangelo is clear, and is also revealed in other drawings from the
same period. These include a figure (fig. 4; see also detail 5), perhaps intended for a
lookout in the background of the *Battle of Cascina*, whose pose is inspired by a cele-
brated antique marble, the *Apollo Belvedere*, and by a fragmentary study of a young
man with a loop of drapery over his shoulder and flame-like curls reminiscent of Roman
portrait busts (fig. 7). The lookout figure is also studied on both sides of another
sheet (figs 8 and 9). On the recto of this is a pen sketch for the smaller than life-size
marble *Virgin and Child*, known as the *Bruges Madonna*, sent to Flanders in 1506.

Michelangelo's years in Florence (1501–5) were among the busiest of his career.
His drawings sometimes bear witness to the way in which his thoughts turned from

one project to another in rapid succession. For example, in fig. 5 (the verso of fig. 4) Michelangelo explored different poses for the Christ Child and the Infant Baptist for the *Taddei Tondo* (now in the Royal Academy in London), one of two unfinished circular marble reliefs made during these years. The drawing was inspired by Leonardo's practice of quickly penning a stream of variant ideas for a pose or composition. The fruits of Michelangelo's study of his rival's battle mural for the Palazzo Vecchio can be seen in the plan to include a cavalry engagement in the background of his own composition. A preliminary idea of this motif is included in fig. 6, alongside two studies for one of the twelve sculptures of the Apostles planned, but never executed, for Florence cathedral (see also detail 6).

Early in 1505 Michelangelo left Florence for Rome, summoned by Pope Julius II to create a grandiose tomb for the old basilica of St Peter's. The delays in realizing this ambitious project overshadowed much of his career. The matter was finally, if unsatisfactorily, resolved in 1545, when a much-reduced version of Julius' tomb was erected in the Roman church of S. Pietro in Vincoli. The first of many distractions was due to Julius himself, who in 1508 commissioned Michelangelo to fresco the vault of the Sistine chapel in the Vatican. The initial idea was to paint enthroned Apostles in the spaces between the windows, with the main area of the ceiling filled by decorative geometric panels. This scheme is recorded in a rare early study (fig. 10). Michelangelo's eventual solution was infinitely richer and more daring: a vast array of figures arranged around a fictive architectural structure and a narrative series of scenes in the main part of the vault showing God's creation of the world and man's early history, as recounted in Genesis, the first book of the Bible. Surrounding these compartments are diversely posed *ignudi* – seated muscular nudes who hold up garlands. Preliminary ideas for these are found on both sides of figs 11 and 12 – quick pen variations on the recto and a study in greasy black chalk of a bull-like torso on the verso. Michelangelo's homosexuality certainly influenced his

Detail 6 (from fig. 6)
Pen and brown ink, *c.* 1503–4.

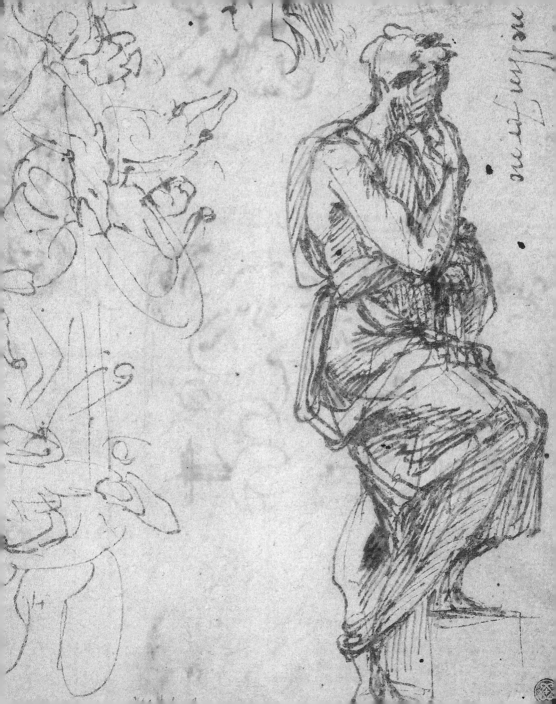

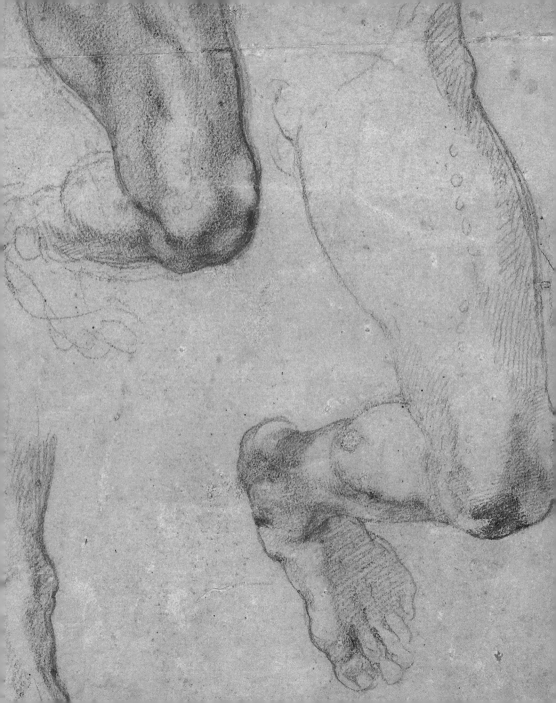

immensely tactile description of the ceiling's male nudes, but their idealized bodies also exemplified the theological belief that man's beauty mirrored the perfection of God who had created Adam in his image.

Michelangelo's drawings for the ceiling make clear the immense thoroughness of his preparation. They include a drapery study in pen and wash for one of the Sibyls painted in the area between the windows (fig. 13). Following traditional Florentine practice, this was drawn from a small wooden figure on which cloth, probably dipped in wet clay to make the folds stiff, had been arranged. But above all, his life studies are among the most beautiful and influential drawings of the male nude ever made. The majority are in red chalk, the medium that best matched the bright tonality of the frescoes required for the figures to be visible in the chapel's gloom. In the life study for Adam (fig. 14), Michelangelo characteristically paid greatest attention to the lighting and musculature of the torso – the area of the body that most forcefully communicated an impression of movement. As was his normal practice in life studies, he only indicated the position of the head, as he would have made a separate study of this detail. On the reverse (fig. 15) there is just such a drawing, related to one of the nearby *ignudi*. The proximity of the two figures on the ceiling indicates how Michelangelo prepared the fresco section by section as he painted it, with minimal studio assistance. His mastery of foreshortening by the time he finished his work can be seen from the crucified Haman painted in one of the corners at the altar end of the chapel. A life drawing for Haman (fig. 16) – his limbs presumably kept aloft with the help of supports – demonstrates Michelangelo's assured use of light to establish the figure's volume and to describe the varying planes of the body. He recorded the area of greatest highlight with a line of small circles, most visible in the thigh of the separate study of the left leg (detail 7). He was still employing this notation thirty years later in his studies for the *Last Judgement* (see fig. 47 and front cover).

Detail 7 (from fig. 16)
Red chalk, *c.* 1511–12.

The completion of the ceiling in 1512 allowed Michelangelo to return to work on Julius' tomb, and for the next three years he was not interrupted further by papal commissions because Giovanni de'Medici, elected as Leo X early in 1513, favoured the work of Raphael. Michelangelo's jealousy of his younger rival's ascendancy found an outlet in his support for the Venetian-born painter Sebastiano del Piombo. He helped his ally by providing him with drawings, such as the two chalk studies for Sebastiano's *Flagellation of Christ*, painted around 1520 in the Roman church of S. Pietro in Montorio. A red chalk design from 1516 (fig. 17; see also detail 8) is Michelangelo's earliest known idea for the whole composition. He also sent Sebastiano an atmospheric study in black chalk (fig. 18) for the powerfully built figure of Christ bound to the column. Leo's cousin, Giulio de'Medici (subsequently elected Pope Clement VII in 1523), shrewdly exploited the rivalry by commissioning pendant altarpieces from Raphael and Sebastiano in 1516. Michelangelo helped to compose parts of Sebastiano's *Raising of Lazarus* (National Gallery, London), and two drawings document the evolution of Lazarus' pose. In the earlier study (fig. 19), the posture of the resurrected figure is a modified variant of the thematically linked figure of Adam in the Sistine chapel. This idea was rejected in favour of a more angular rendering, as though Lazarus' limbs were still stiff from death, which was developed in fig. 20.

In 1516 Leo ordered Michelangelo to return to Florence to work on Medici projects in the family church of S. Lorenzo. A grandiose plan for a marble façade foundered three years later, but Michelangelo was redirected to create a Medici funeral chapel at the north end of the church. Later he was asked to design a library attached to the cloister. For the walls of the Medici chapel Michelangelo planned two single and one double tomb richly embellished with marble figures. A two-sided drawing relates to the development of the unrealized double tomb (figs 21–2). The rapid changes of mind concerning the position and structure of the left-hand niche in fig. 21 give a vivid impression of Michelangelo's evolving ideas. The River Gods shown

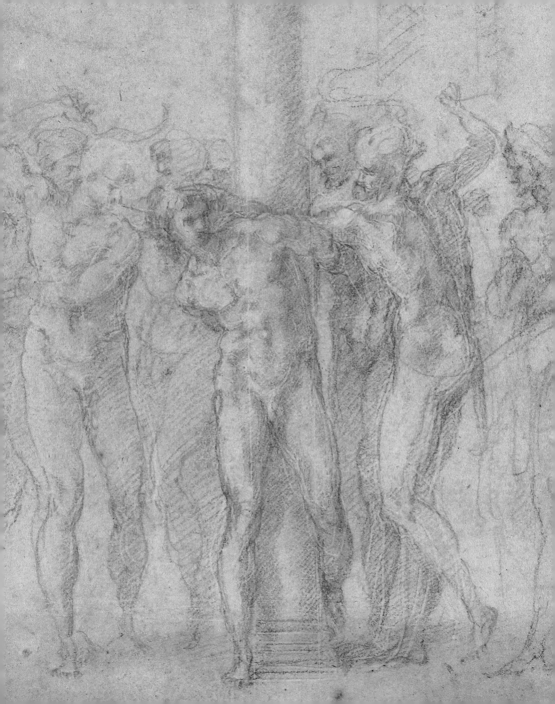

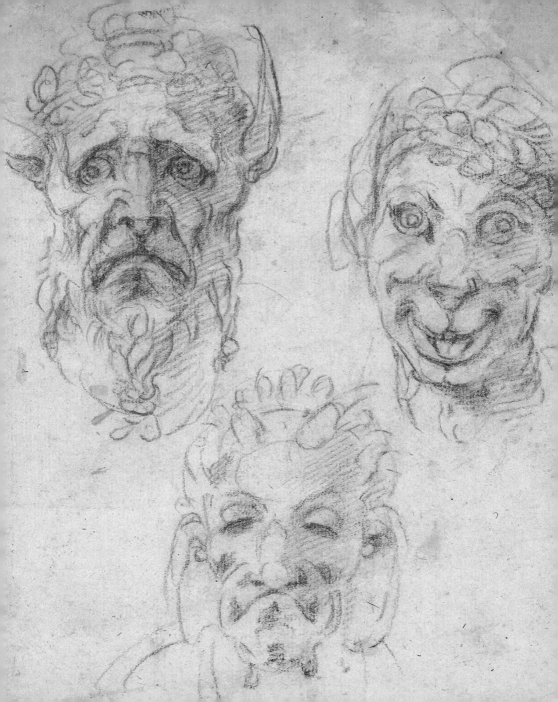

at the base of the more fully developed drawing for one of the single tombs (fig. 23) were never carved, but their dimensions are recorded in Michelangelo's schematic diagram made for the quarrymen to find him suitable marble blocks (fig. 24). In the second half of the 1520s Michelangelo was working on the Medici chapel while also supplying designs for the library. An example of a drawing for the second project is the double-sided sheet with pen studies for both sides of the doorway to the vestibule (figs 25–6).

During his time in Florence Michelangelo made efforts to teach a small group of pupils to draw by producing examples for them to copy. An inkling of his teaching style can be gleaned from his stern admonition to his assistant Antonio Mini, written on fig. 27: 'Draw Antonio draw Antonio, draw and don't waste time' (a detail of this is on p. 61) Mini's lack of talent is apparent from the quality of his red chalk copies of Michelangelo's pen drawings on the sheet. An unknown pupil's effort to replicate the head of a girl on another sheet (fig. 28) was so poor that Michelangelo covered it up by drawing a figure sitting in a chair spinning (the copy is just visible in the area of the left forearm). The fanciful pen drawing of a woman on the recto of a double-sided drawing (figs 30–31) is perhaps another example of Michelangelo using his pupil's efforts – in this case the red chalk underdrawing – as a stimulus for his own invention. A diminutive bending figure he had drawn earlier is seemingly incorporated into the design so that the female figure appears gigantic. The amusing and grotesque half-human, half-animal heads in red chalk (fig. 29; see also detail 9) shed a more sympathetic light on Michelangelo's teaching methods. These were probably created as diverting models for his pupils to copy. The beginning of a feeble version of one of them is just visible on the left. A similar impulse motivated his red chalk drawings on one sheet of a young boy with a flute, a screaming devil and a defecating man (fig. 33). Michelangelo used the unused side of the sheet to make one of his most exquisite studies of the period, a profile head of a woman of a manly cast of

Detail 9 (from fig. 29)
Red chalk and stylus, c. 1524–5.

beauty (fig. 32). This tour-de-force demonstration of his imaginative and technical mastery was probably made as a gift for a member of his circle.

Michelangelo's insistence on giving finished drawings to his friends, rather than to his patrons who craved such refined works, is just one expression of his deter` `minedly independent nature. His desire to set himself apart from his fellow artists is demonstrated by his unwillingness to turn his hand to portraiture. However, on at least two occasions, Michelangelo is known to have drawn handsome young noblemen of his acquaintance. The only certain surviving example depicts the Florentine Andrea Quaratesi (fig. 34 and back cover) and was executed around 1530. Michelangelo is known to have given the sitter drawing lessons, and the Quaratesi may have sheltered him when he feared for his life after the Medici had retaken control of Florence following the fall of the second Florentine Republic in 1530. In the event, the Medici Clement VII forgave Michelangelo his lack of loyalty, but some have detected the anxiety of the times in his unsettling portrayal of the youth, his face shrouded in shadow while he looks distractedly to the right.

While Michelangelo's energies during these years in Florence (1516–34) were concentrated on Medici projects, his drawings show his readiness to explore unrelated ideas. A red chalk drawing of the Crucifixion may be connected to a commission from a Venetian cardinal in 1524 for a devotional work (fig. 35). Patrons and artists frequently called on Michelangelo's talent as a designer, and a series of drawings of the Risen Christ from the early 1530s may have been prompted by such a request. The two examples in the British Museum (figs 36–7) highlight his ability to interpret a sacred episode in novel and varied ways. In fig. 37 the upward movement of Christ's body seems to anticipate his imminent ascent to heaven. By contrast, the equally attenuated figure in fig. 36 seems poised to spring earthwards from the top of the sarcophagus. In both drawings Christ's body is free from wounds and, as if to emphasize further the break with his earthly incarnation, his eyes are closed.

Detail 10 (from fig. 38)
Black chalk, c. 1532–3.

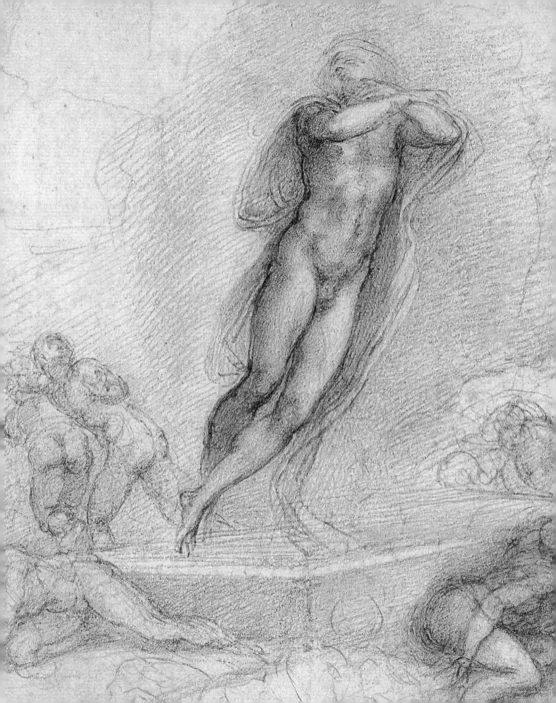

Michelangelo's reflection on the nature of Christ's risen form culminated in a vision-ary drawing of the Resurrection showing his unconscious body floating effortlessly free from the tomb (fig. 38; see also detail 10).

The unconventional nature of this drawing reveals how the medium offered Michelangelo an outlet to explore ideas with complete freedom. This unfettered, individualistic approach can be seen again in two black chalk studies from the early 1530s depicting the Virgin and Child (figs 39–40). In the first, the monumental figure of the seated Virgin gazes down at her muscular young son romping with his cousin, St John the Baptist. The childish play is undercut by the wistful sadness of the Virgin's expression, suggesting her knowledge of their fate. The maternal bond is expressed with yet greater intensity in fig. 40, in which Christ swivels backwards to suckle, watched to the right by the sketchily drawn figures of St Joseph and the Infant Baptist. Michelangelo reinforces the unity of the mother and child by their shared nakedness. Such a breach of decorum in the depiction of the Virgin would have been impossible to replicate in a painting or sculpture for public view.

Michelangelo's eighteen years in Florence ended in 1534 with his definitive return to Rome. Neither the Medici chapel nor the library had been brought to completion, but the artist was anxious to leave Florence to rejoin a young Roman nobleman more than forty years his junior, Tommaso de'Cavalieri, with whom he had fallen passionately in love. This newfound emotion inspired him to write love poetry and make drawings for his beloved. One of them is a study for a *Fall of Phaeton* (fig. 41; see also detail 11) that bears a note written by the artist at the bottom: 'Messer Tommaso, if this sketch does not please you, say so to Urbino [the artist's servant] in time for me to do another tomorrow evening, as I promised you; and if it pleases you and you wish me to finish it, send it back to me.' It depicts the Roman poet Ovid's story of Phaeton falling to earth after being destroyed by Jupiter's lightning bolt because he had lost control of the chariot of the sun, which he had rashly borrowed

Detail 11 (from fig. 41)
Black chalk and stylus, 1533.

from his father Apollo. In his poetry Michelangelo frequently likened love to the destructive powers of fire, and in this gift to Cavalieri he was surely identifying himself with the scorched Phaeton plunging to earth.

The artist came to Rome to paint the altar wall of the Sistine chapel with a representation of the Last Judgement: the end of the world when Christians believe their bodies will rise again and be judged by Christ. Michelangelo's work, painted in 1536–41, replaced the traditional symmetrical arrangement of the scene with a swirling maelstrom of thickset naked figures, centred on the majestic figure of Christ. The nudity of the figures, despite the deliberately unsensuous forms that Michelangelo adopted in the fresco, was heavily criticized by some of his contemporaries, and draperies were added to many of the figures soon after the artist's death (these additions still remain). One of a handful of surviving compositional studies is a densely worked and energetic sheet for the right-hand group of saints, as they look down at angels repelling the ascent of condemned souls (fig. 42; see also detail 12). The verso demonstrates how Michelangelo made use of drawings to secure an astonishing variety of poses and individual expressions in the fresco (fig. 43). On the right he traced through some of the figures from the other side of the sheet, thereby reversing their poses, and to the left he made a life drawing of the head of a male model from two slightly different angles.

Michelangelo would have gone on to make individual life drawings for most of the figures, but few survive. An idea of their quality is provided by a double-sided study (figs 44–5) for two of the figures in the section of the work sketched out in fig. 42. In the fresco, the angel pummelling down a sinner studied on the recto (fig. 44) is in close proximity to the condemned soul prepared on the verso (fig. 45). This shows Michelangelo's adherence to the piecemeal approach to preparing the composition that he had adopted for the Sistine vault. The more generalized description of the flying angels for the upper right corner studied in fig. 46 perhaps indicates that

Detail 12 (from fig. 42)
Black chalk, c. 1534–6.

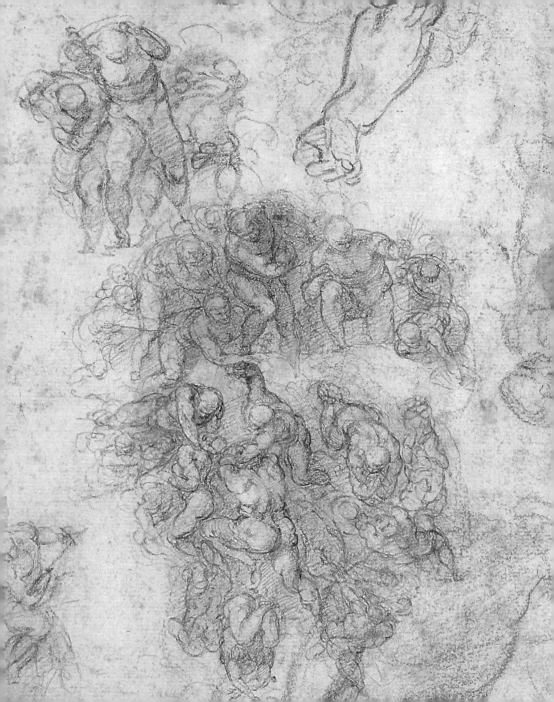

they were drawn after wax figures that Michelangelo is recorded as having used as models for the fresco. For economy of effort Michelangelo probably calibrated the level of detail according to the location of the figure in the work. Only the more visible figures in the lower half of the work required detailed study of their surface modelling. This explains the exquisite description of the arms and shoulder blades of a model for a soul emerging from the earth at the lower left corner (fig. 47 and front cover). On the verso (fig. 48) are life studies for the torso of a figure on the far left edge of the fresco and for the hands of the monk standing behind him.

The *Last Judgement* and a commission to fresco the Pauline chapel in the Vatican (1542–50) again impeded Michelangelo's work on Julius II's tomb; yet it was in his interest to stay on good terms with the late pope's increasingly impatient heir, the duke of Urbino. The artist is known to have made him a small model for a bronze horse, and designed a silver salt-cellar in 1537. Neither survives, but the appearance of the latter is known from Michelangelo's black chalk drawing for it (fig. 49). His design wittily alludes to the differing nature of love with the winged Cupid on the lid threatening all who touch the vessel, while below him the lascivious grin of the satyr suggests an earthier physical expression of the emotion.

The last three decades of the artist's life were dominated by architectural projects, in particular his appointment in 1546 to oversee the construction of St Peter's. This field of activity is poorly represented in the British Museum, although compensated for by the quality of the collection of his late figure drawings. These works testify to Michelangelo's deepening religious faith, stimulated by his friendship from the late 1530s with the aristocratic poet, Vittoria Colonna, an important figure in the movement for Catholic reform in Rome following the Protestant revolution north of the Alps. Michelangelo made three devotional black chalk drawings for Colonna before her death in 1547, one of which is the *Crucifixion* (fig. 51). This is a highly emotive treatment, showing Christ still alive and suffering on the cross, his agonies

watched by weeping angels. Christ's sacrifice is the subject of another finished black chalk drawing from the same period (fig. 50). The pathos of the scene is heightened by the contrast between the Virgin turning away in grief from Christ's broken body and the surging movement towards the corpse by the figures behind her.

Michelangelo gave up painting after 1550, but this did not prevent him from supplying designs for a small coterie of painters. Two drawings from the late 1540s of the Annunciation (figs 52–3) were made for the northern Italian artist Marcello Venusti, to help him paint two versions of the subject for Roman churches. In the second Michelangelo had the innovative idea to show the Angel Gabriel whispering in the Virgin's ear. Michelangelo also provided drawings in the latter half of the 1550s (figs 54–5) for a small-scale painting attributed to Venusti, *Christ Purifying the Temple* (now in the National Gallery in London). During the same period he made a cartoon of the Holy Family and other figures as a guide for a painting by Ascanio Condivi. The cartoon (fig. 56) was erroneously described as an 'Epifania' (Epiphany or the Adoration of the newborn Christ by the three kings) in a posthumous inventory of Michelangelo's studio.

The artist's increasingly spiritual turn of mind is voiced in one of his most celebrated late sonnets: 'Neither painting nor sculpting can any more quieten my soul, turned now to that divine love which, on the cross to embrace us, opened wide its arms.' His meditation on the significance of Christ's sacrifice in relation to his own approaching end also inspired him to make a small group of drawings of the Crucifixion, probably for his personal devotional needs. Two of these intensely moving works, executed in black chalk with thin layers of white heightening, used like a correcting fluid to cover over his changes of mind, are in the British Museum (figs 57–8). Michelangelo's devotional fervour is made manifest in his obsessive reworking of the outlines of the Virgin and St John, who react in differing ways to Christ's death in the two drawings. These works testify to Michelangelo's undiminished powers as a draughtsman in old age, and make clear that drawing remained a vital means of expression right until the end of his life.

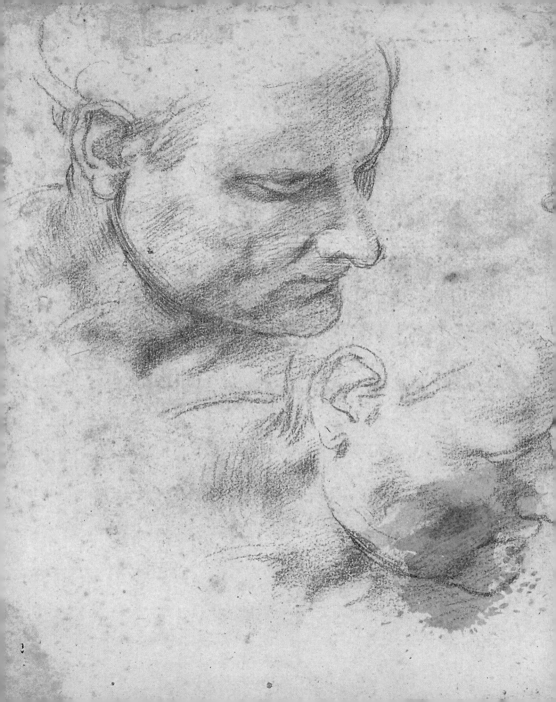

Michelangelo Drawings

1

**An old man wearing a hat
(*Philosopher*)**, *c.* 1495–1500.
Pen and brown ink, 33.1 × 21.5 cm.

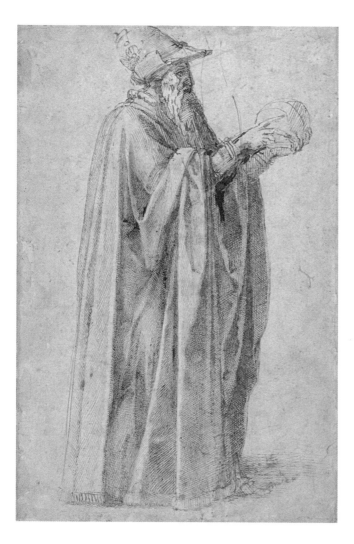

opposite
2
Head of a youth and a right hand,
c. 1508–10. Red and black chalk over
stylus, gone over with pen and brown
ink (the head); black chalk (the hand),
33.1 × 21.5 cm. Verso of fig. 1.

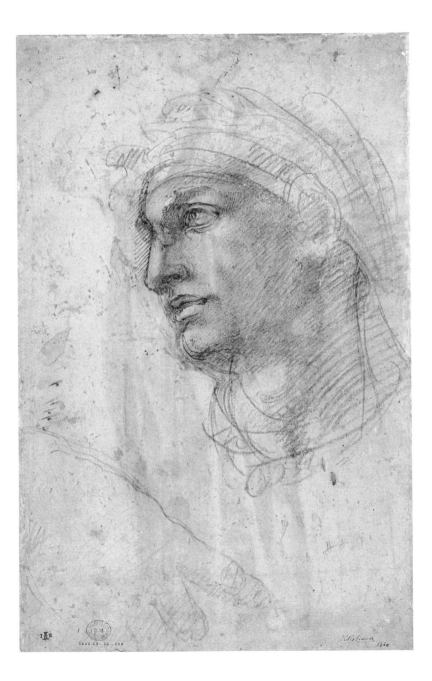

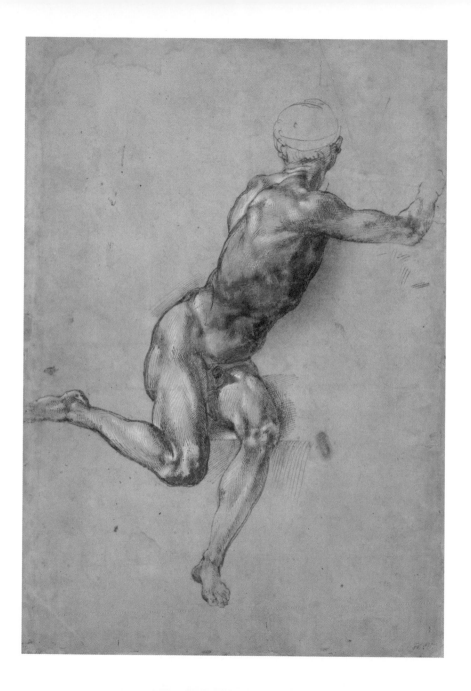

4
A youth beckoning; a right leg,
c. 1504–5. Pen and brown ink; black
chalk, 37.5 × 23 cm.

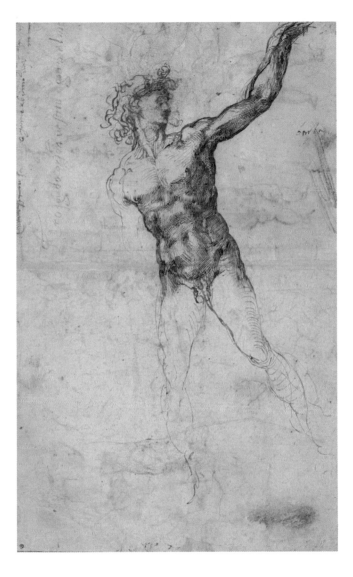

opposite
3
**A seated male nude twisting
around**, *c.* 1504–5. Pen and brown ink,
brown and grey wash, heightened with
lead white (partly discoloured) over
leadpoint and stylus, 42.1 × 28.7 cm.

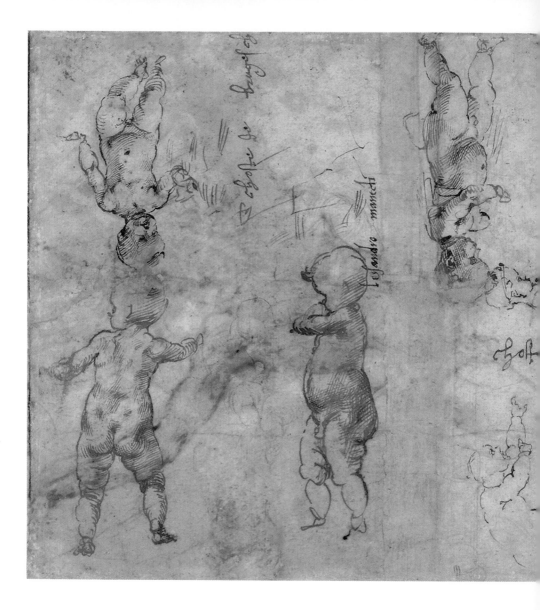

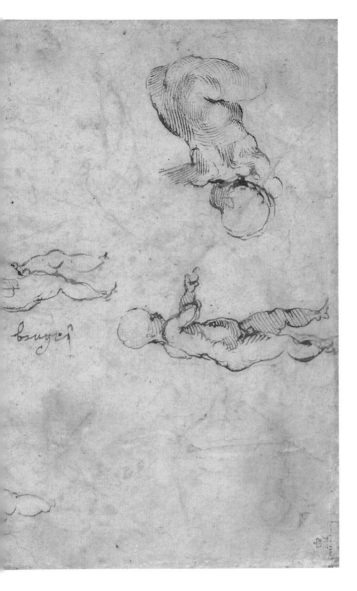

5
Studies of infants, *c.* 1504–5.
Pen and brown ink over black chalk,
four infants not finished in pen and ink,
23 × 37.5 cm. Verso of fig. 4.

6

A battle-scene; two figures,

c. 1503–4. Pen and brown ink,
18.6 × 18.3 cm.

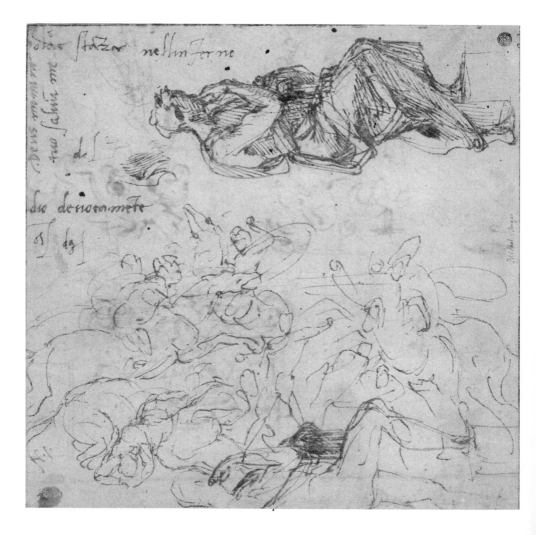

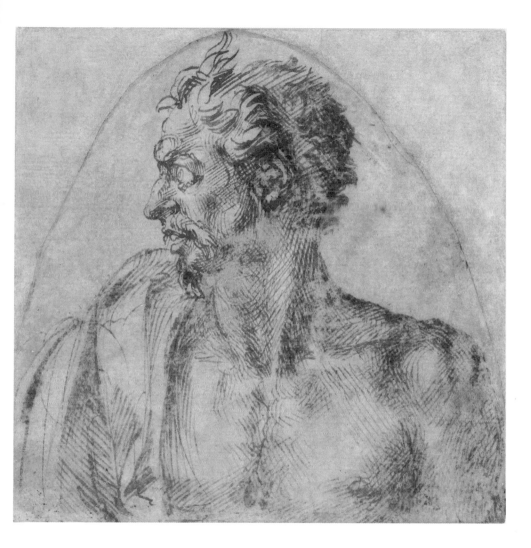

7

Head of a man in profile, *c.* 1500–5.
Pen and brown ink, cut at the top
to a half-oval and later made up
to a square, 13 × 13 cm.

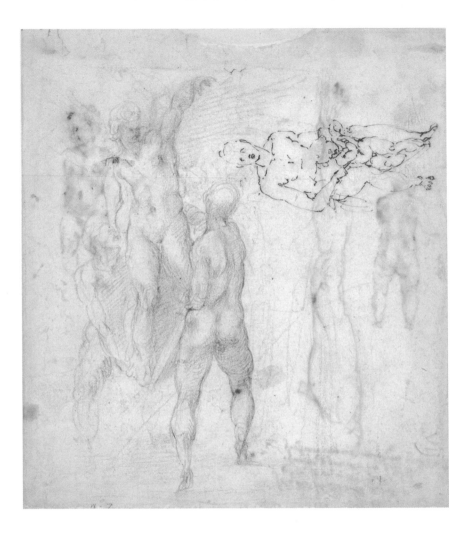

8

A group of three nude men; the Virgin and Child, *c.* 1504–5. Black chalk (the nudes); pen and brown ink over leadpoint (the Virgin and Child), made up section of paper at centre of upper edge, 31.5 × 27.8 cm.

opposite
9

Two putti; a nude; a left leg, *c.* 1504–5. Pen and brown ink; black chalk (the nude), made up section of paper at centre of upper edge, 31.5 × 27.8 cm. Verso of fig. 8.

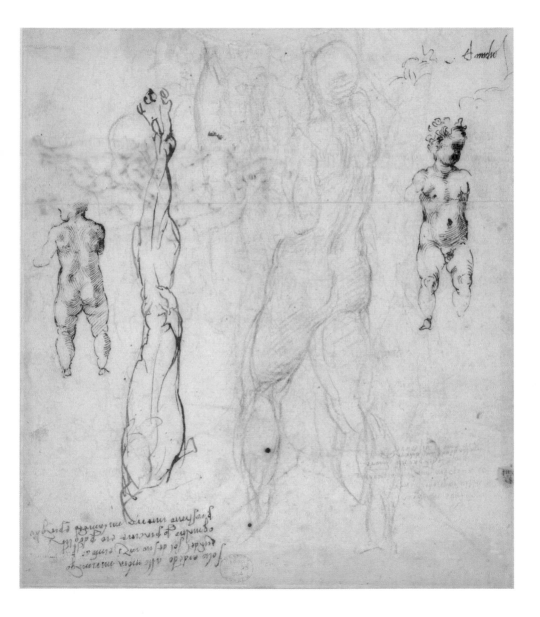

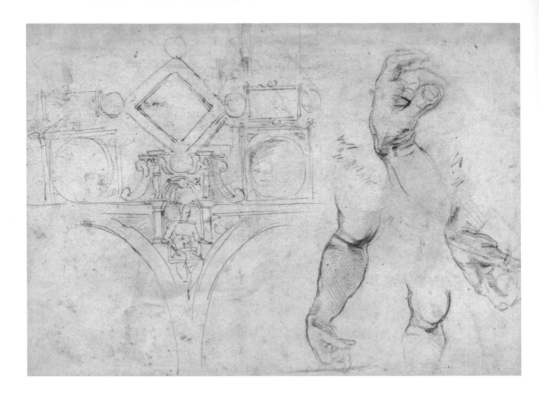

10
**Scheme for the Sistine chapel
ceiling; studies of arms**, *c.* 1508.
Pen and brown ink over leadpoint
and stylus (main study); black chalk
(arm studies), 27.5 × 38.6 cm.

11
**One kneeling and three seated
nude men**, *c.* 1508. Leadpoint and
pen and brown ink, 18.8 × 24.5 cm.

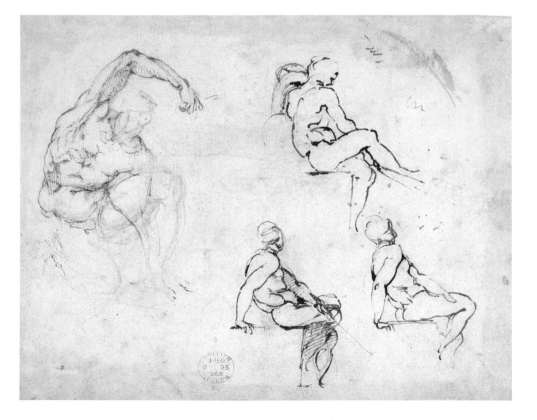

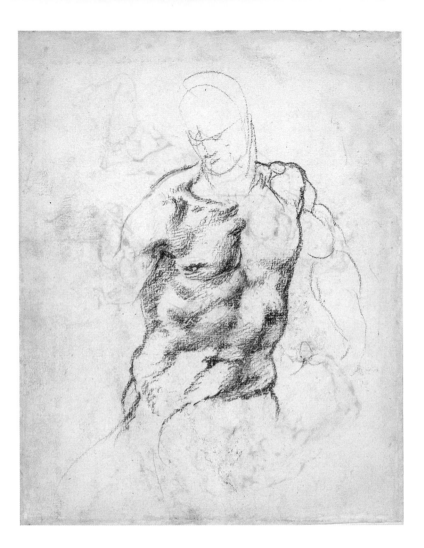

12
A male torso, *c.* 1508. Black chalk,
24.5 × 18.8 cm. Verso of fig. 11.

opposite
13
The Erythraean Sibyl, *c.* 1508–9.
Black chalk, pen and brown ink and
brown wash, made up section of
the paper at the lower right corner,
38.7 × 26 cm.

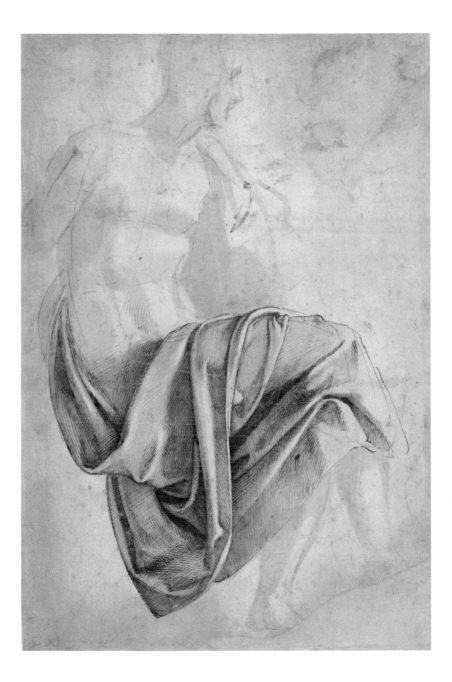

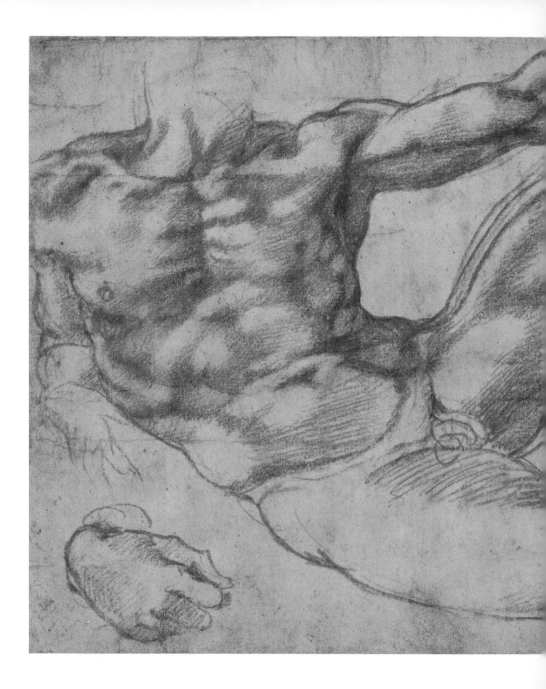

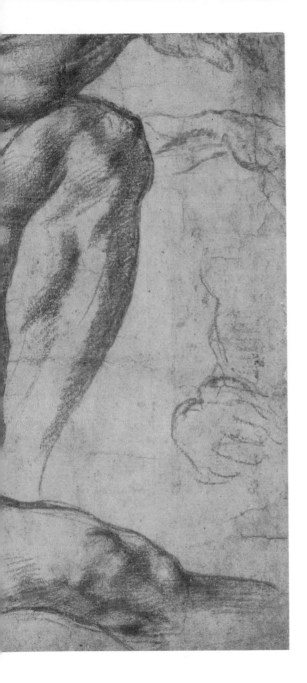

14
Study for Adam, *c.* 1511. Red chalk,
made up sections at lower edge,
19.3 × 25.9 cm.

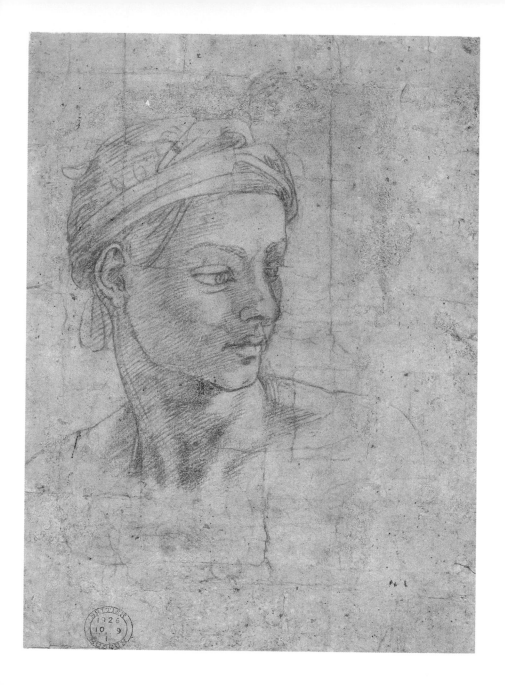

16
Studies for Haman, 1511–12. Red
chalk, made up section of the paper
at upper right corner, 40.6 × 20.7 cm.

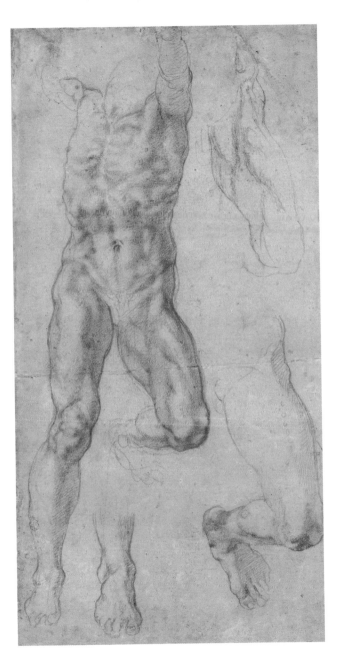

opposite
15
Youthful head, *c.* 1511. Red chalk,
the contours traced with a stylus,
made up sections at left edge,
25.9 × 19.3 cm. Verso of fig. 14.

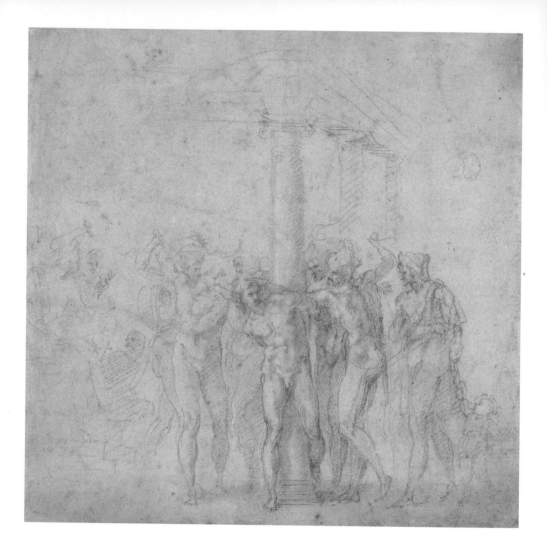

17
The Flagellation of Christ, 1516.
Red chalk over stylus, 23.5 × 23.6 cm.

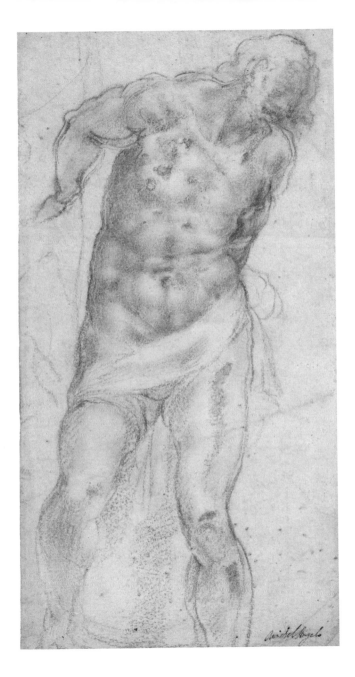

18
Christ at the Column, 1516.
Black chalk, heightened with lead
white (discoloured) over stylus,
27.5 × 14.3 cm.

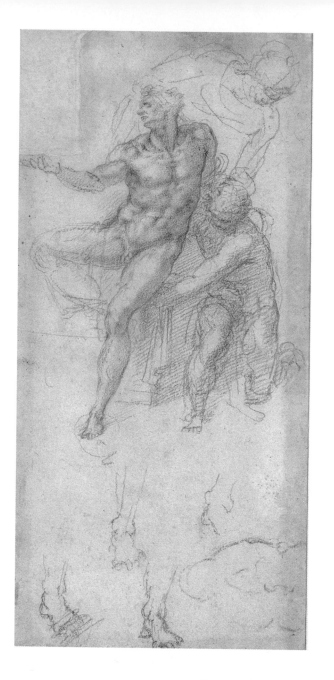

19
Lazarus, 1516. Red and some black chalk, 25.2 × 11.9 cm.

opposite
20
Lazarus, 1516. Red chalk, the left side cut and made up, 25.1 × 14.5 cm.

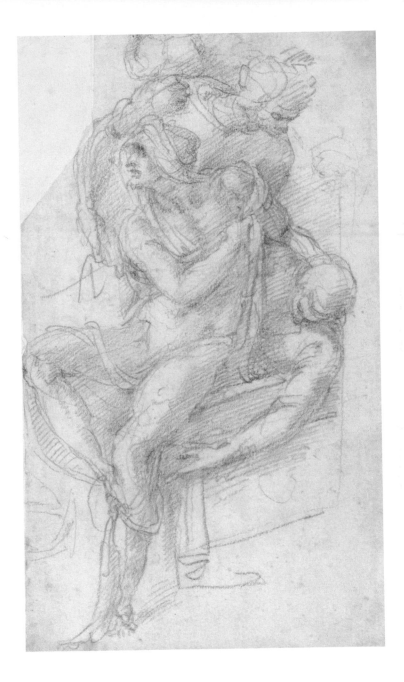

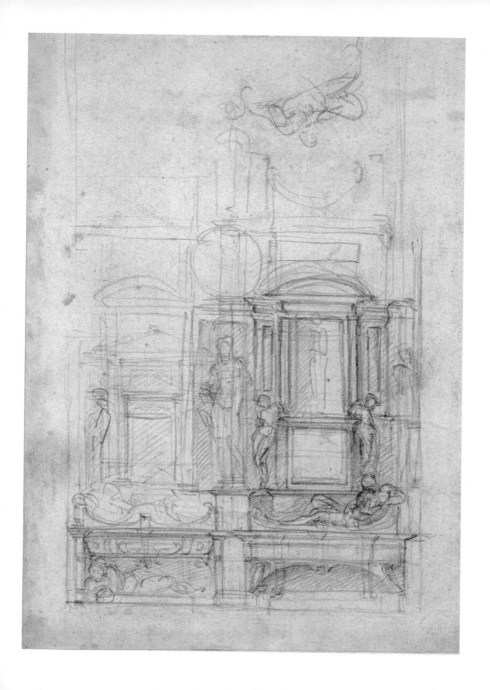

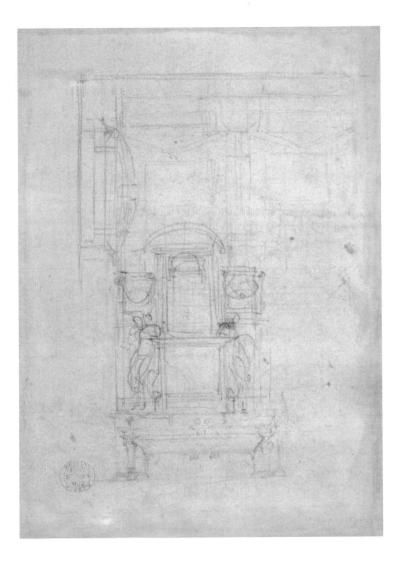

opposite
21
Studies for a double wall tomb,
c. 1520–1. Black chalk, 26.4 × 18.8 cm.

22
Studies for a double wall tomb,
c. 1520–1. Black chalk, 26.4 × 18.8 cm.
Verso of fig. 21.

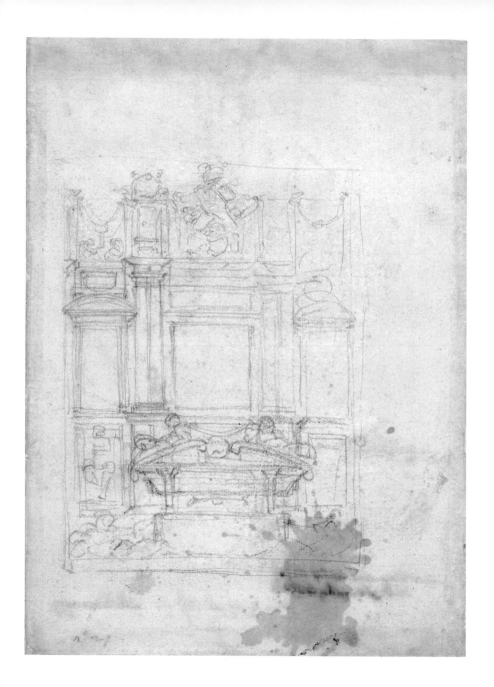

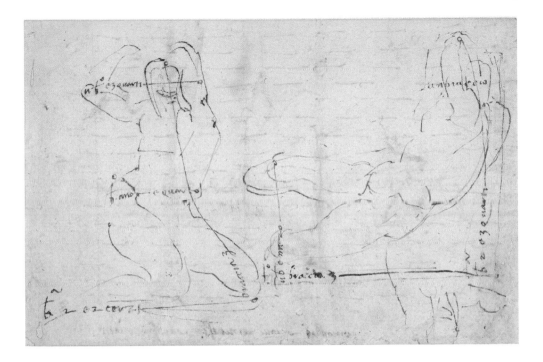

24
**Marble block diagram for a River
God**, *c.* 1525. Pen and brown ink,
13.7 × 20.9 cm.

opposite
23
Study for a single wall tomb,
c. 1520–1. Black chalk, 29.7 × 21 cm.

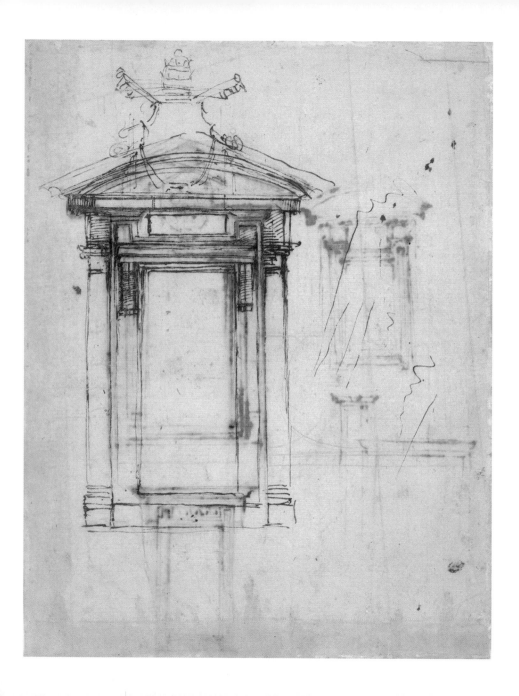

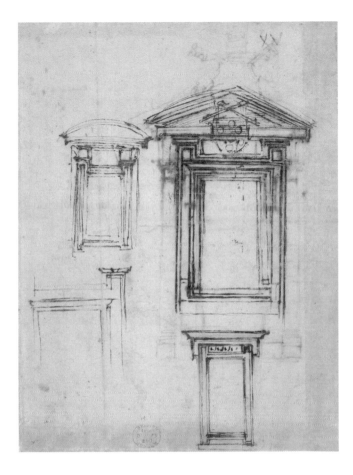

26

**Designs for the Laurentian library
door from the vestibule (*ricetto*)
and an external window**, *c.* 1526.
Pen and brown ink over stylus,
28.4 × 20.9 cm. Verso of fig. 25.

opposite
25

**Design for the Laurentian library
door**, *c.* 1526. Pen and brown ink over
stylus; leadpoint, 28.4 × 20.9 cm.

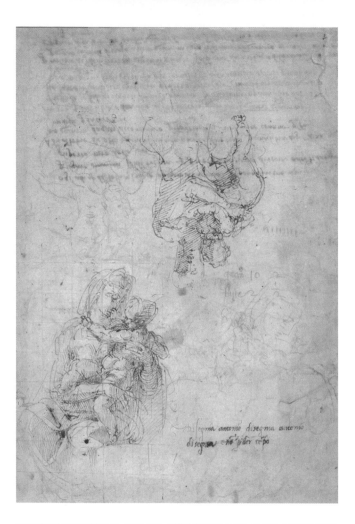

27
Michelangelo and Antonio Mini
(d. 1533), **Studies for a Virgin and
Child**, *c.* 1522–6. Pen and brown ink
(the studies); red chalk (the copies);
black chalk (the squaring and copy),
made up section of paper at upper
right, 39.6 × 27 cm.

Below is a detail of the inscription
in Michelangelo's hand:
'Disegnia antonio disegnia antonio/
disegnia e no[n] p[er]der[e] te[m]po'
('Draw Antonio draw Antonio,
draw and don't waste time').

opposite
28
Michelangelo and pupil, **Girl with
a spindle**, *c.* 1525. Black chalk,
the lower left corner made up,
28.8 × 18.2 cm.

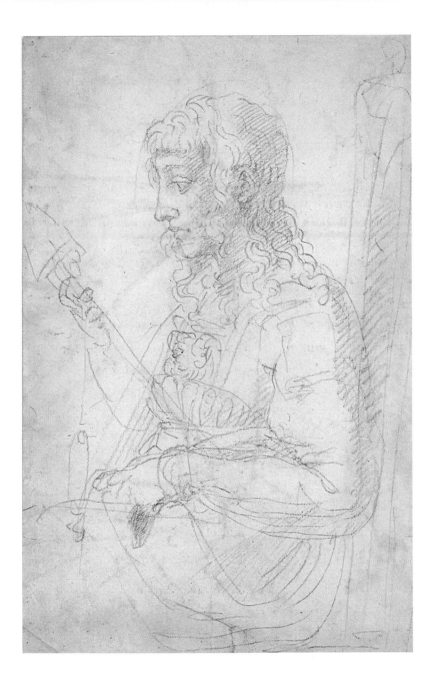

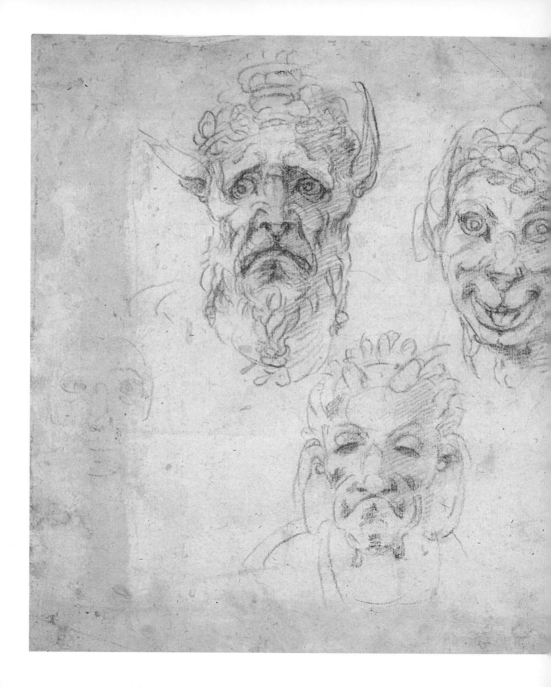

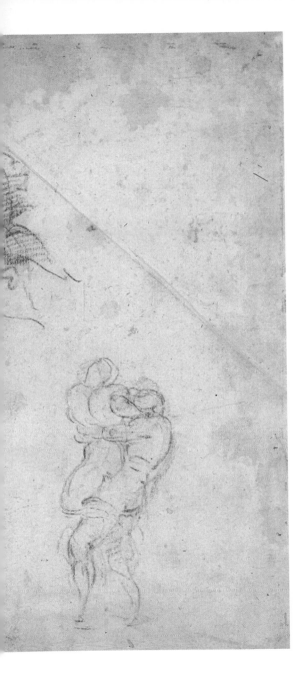

29

**Grotesque heads; *Hercules and
Antaeus***, *c.* 1524–5. Red chalk,
the Hercules sketch over black chalk,
all contours traced with a stylus,
25.5 × 35 cm.

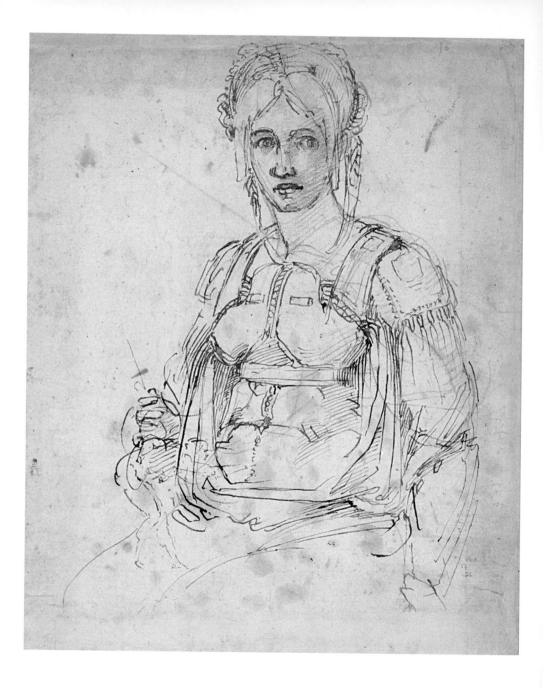

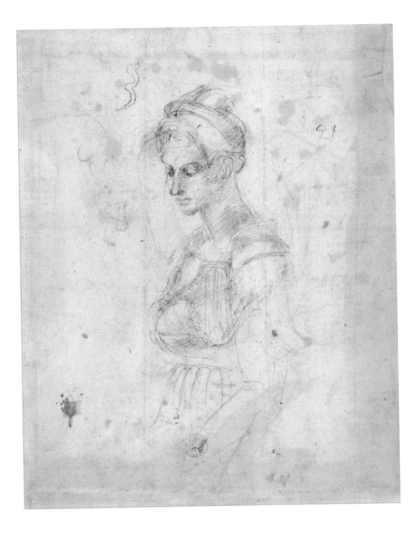

30

Half-length figure of a woman,
c. 1525. Pen and brown ink over red
and black chalk, made up strip at
upper edge and lower right corner,
32.3 × 25.8 cm.

31

Half-length figure of a woman,
c. 1525. Black chalk, made up strip at
the lower edge and upper right corner,
32.3 × 25.8 cm. Verso of fig. 30.

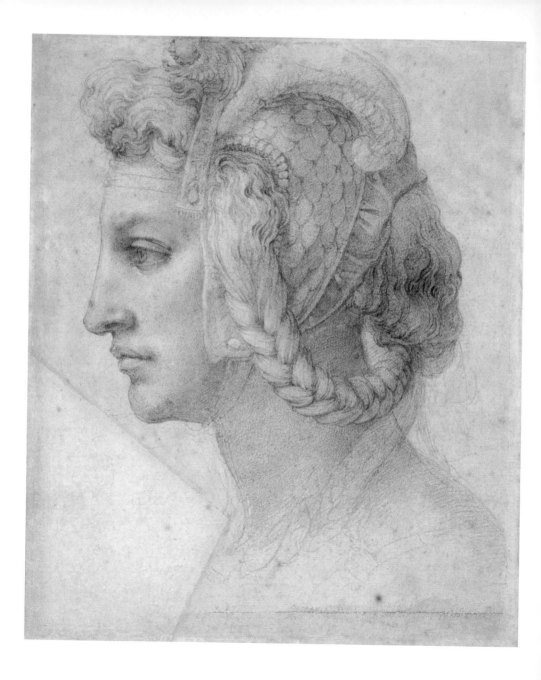

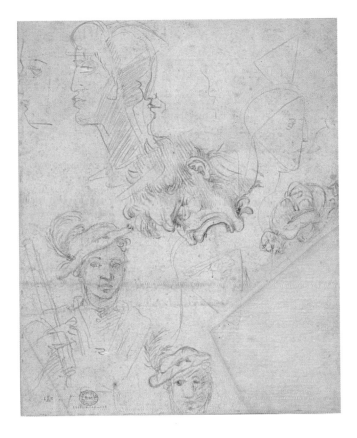

opposite

32

Ideal head of a woman, *c.* 1525–8.
Black chalk, a section of the paper
made up at the lower left corner,
28.7 × 23.5 cm.

33

Michelangelo and pupils, **Heads
and figures**, *c.* 1525–8. Red chalk,
a section of the paper made up at
the lower right corner, 23.5 × 28.7 cm.
Verso of fig. 32.

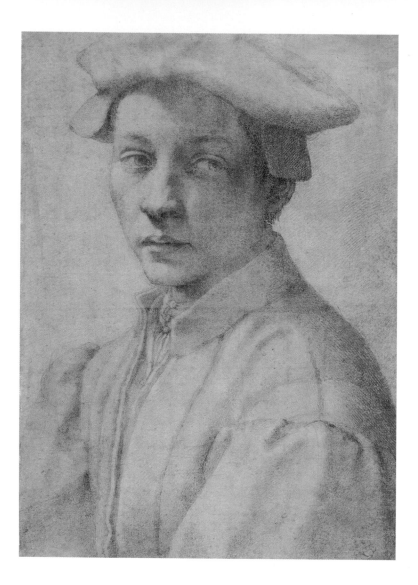

34
Andrea Quaratesi, *c*. 1528–32.
Black chalk, two made up areas
at upper edge, 41.1 × 29.2 cm.

opposite
35
The Three Crosses, *c*. 1523.
Red chalk, 39.4 × 28.1 cm.

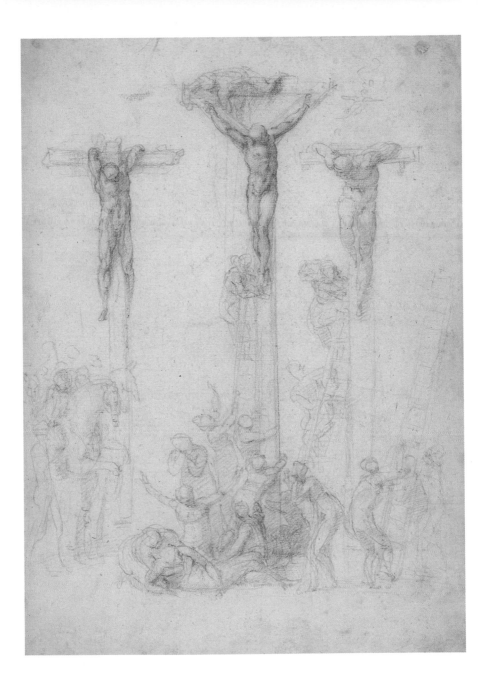

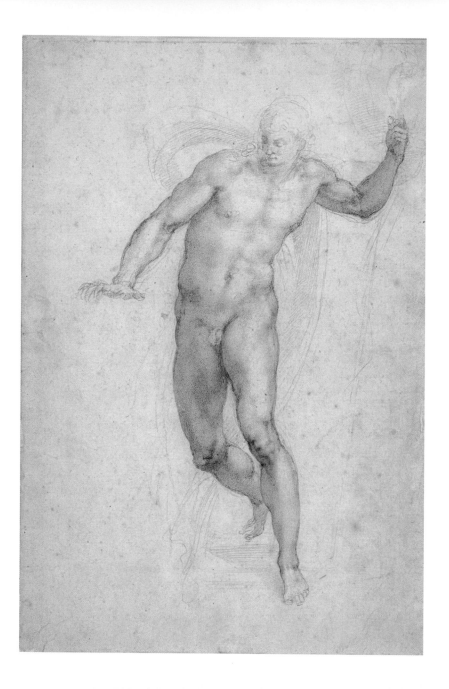

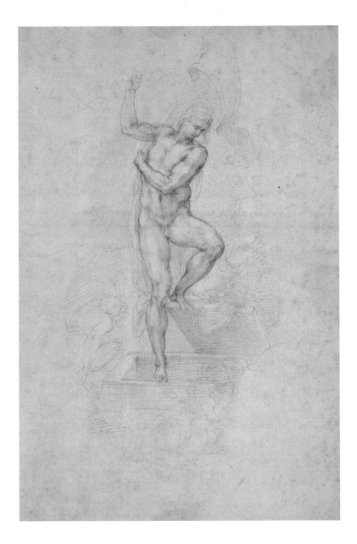

opposite
36
The Risen Christ, *c.* 1532–3.
Black chalk, 41.4 × 27.4 cm.

37
The Risen Christ, *c.* 1532–3.
Black chalk, 40.6 × 27.1 cm.

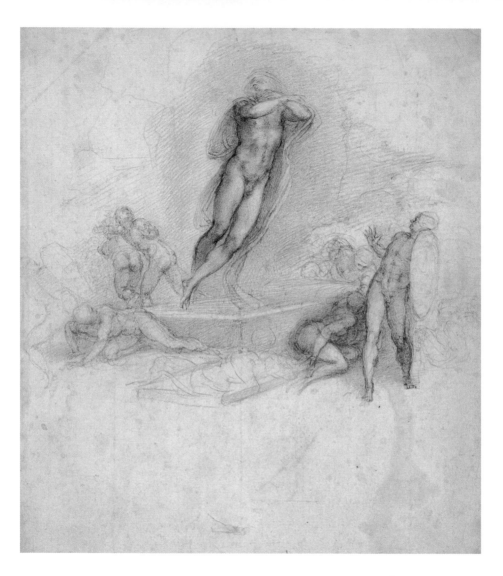

38
The Resurrection of Christ,
c. 1532–3. Black chalk, 32.6 × 28.6 cm.

opposite
39
**The Virgin and Child with the
Infant Baptist**, c. 1530. Black chalk,
31.4 × 20 cm.

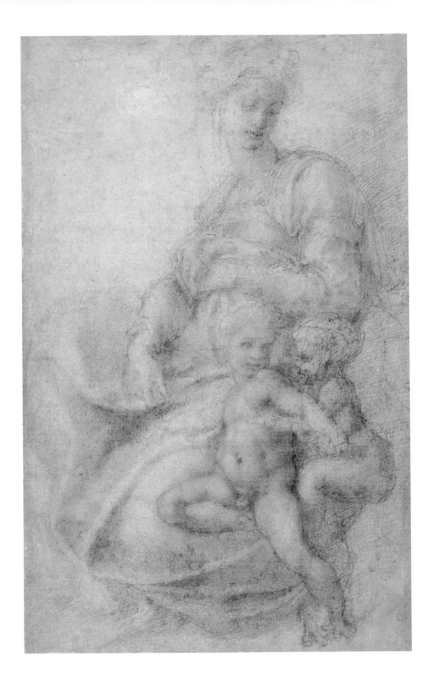

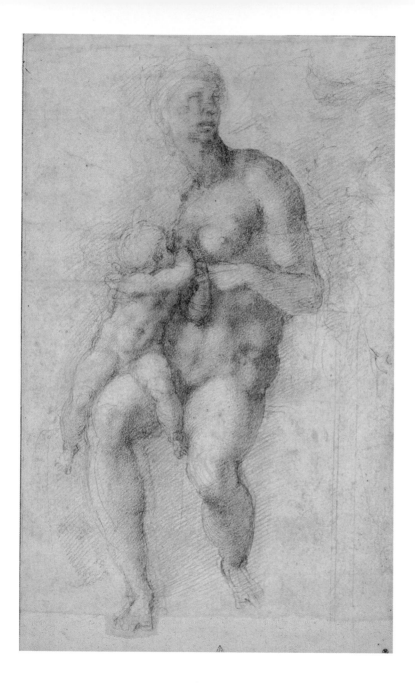

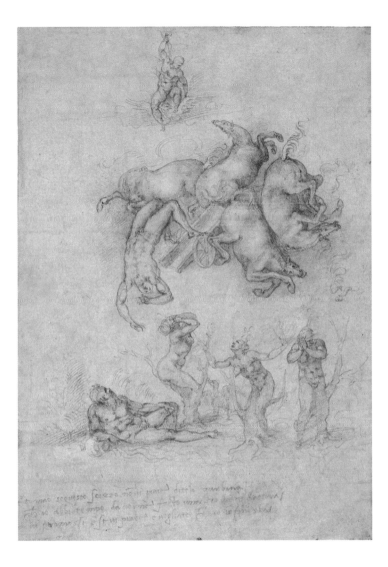

opposite

10

**The Holy Family with the Infant
Baptist**, *c.* 1530–4. Black chalk, the
lower edge (except for the Virgin's
right foot) made up, 31.7 × 19.1 cm.

41

The Fall of Phaeton, 1533. Black
chalk over stylus, 31.3 × 21.7 cm.

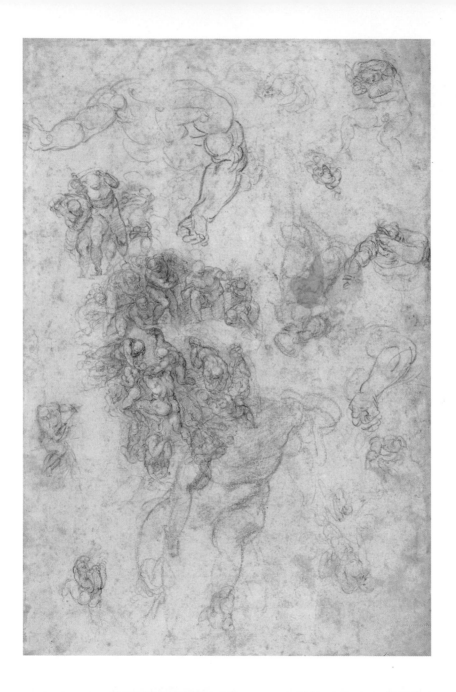

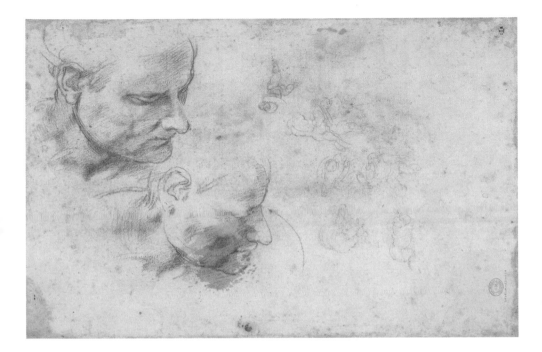

43
Two heads and other studies,
c. 1534–6. Black and red chalk,
25.3 × 38.5 cm. Verso of fig. 42.

opposite
42
Studies for *The Last Judgement*,
c. 1534–6. Black chalk, 38.5 × 25.3 cm.

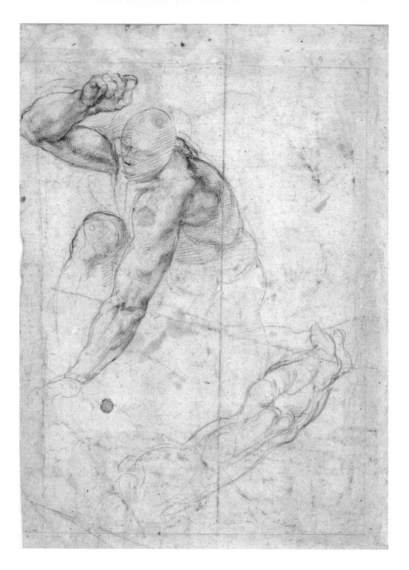

44
A fighting angel, *c.* 1534–6. Black
chalk, 26.2 × 18.1 cm.

opposite
45
A condemned sinner, *c.* 1534–6.
Black chalk, 26.2 × 18.1 cm. Verso
of fig. 44.

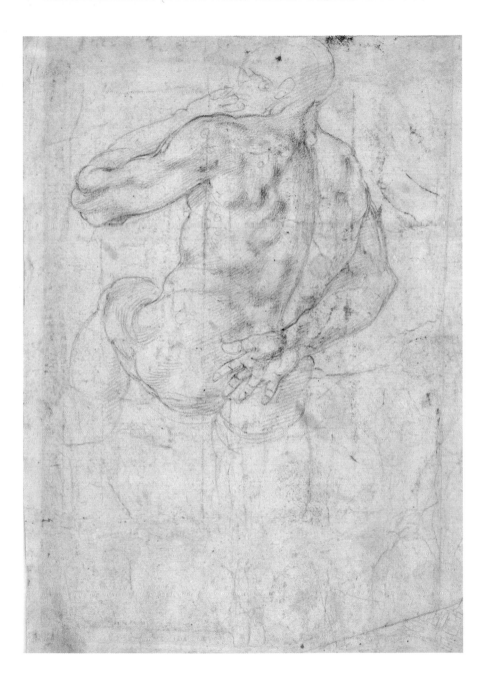

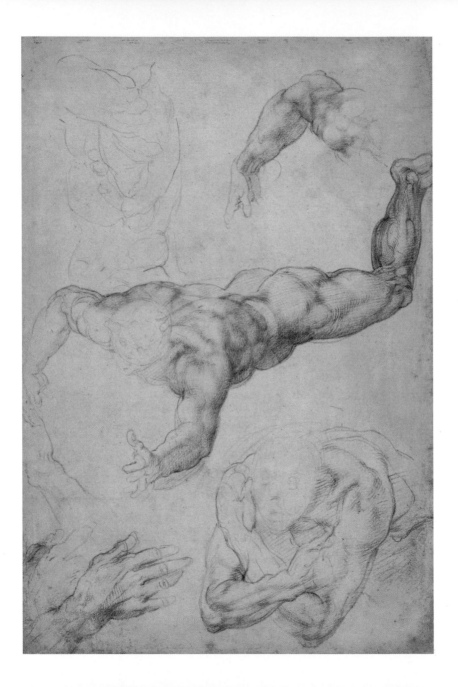

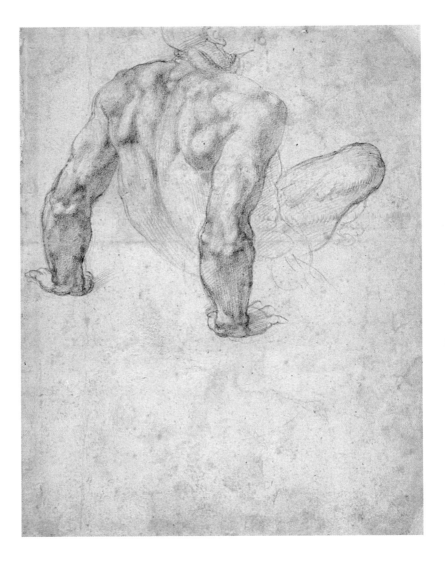

opposite
46

A flying angel and other studies,
c. 1534–6. Black chalk, 40.7 × 27.2 cm.

47
A male nude seen from behind,
c. 1539–41. Black chalk, right
corners and parts of edge made up,
29.3 × 23.3 cm.

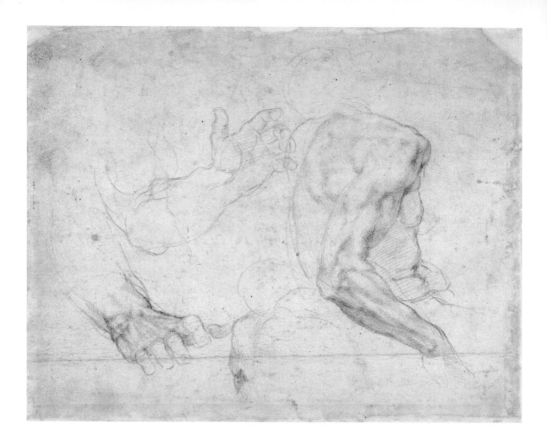

48
A male nude in profile, *c.* 1539–41.
Black chalk, top corners and parts
of the upper edge made up,
23.3 × 29.3 cm. Verso of fig. 47.

opposite
49
Design for a salt-cellar, 1537.
Black chalk, 21.7 × 15.5 cm.

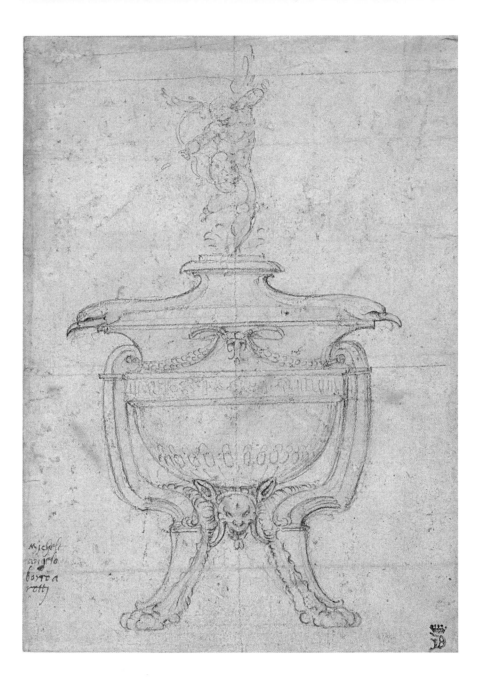

michel
angelo
barroc
ratti

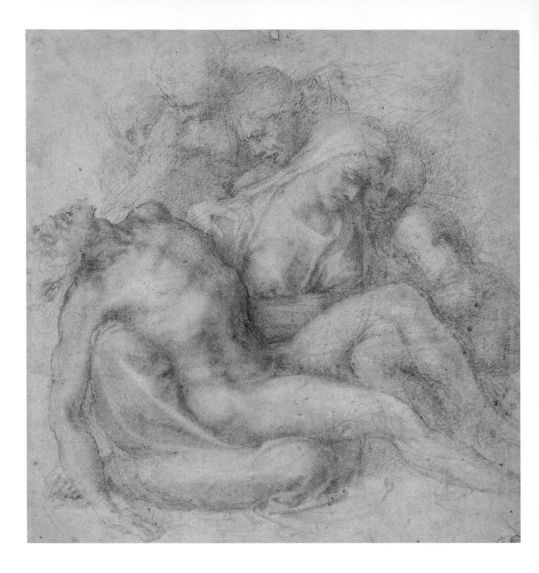

50
The Lamentation, *c.* 1530–5. Black
chalk, 28.2 × 26.2 cm.

opposite
51
Crucifixion, *c.* 1538–41. Black chalk,
37 × 27 cm.

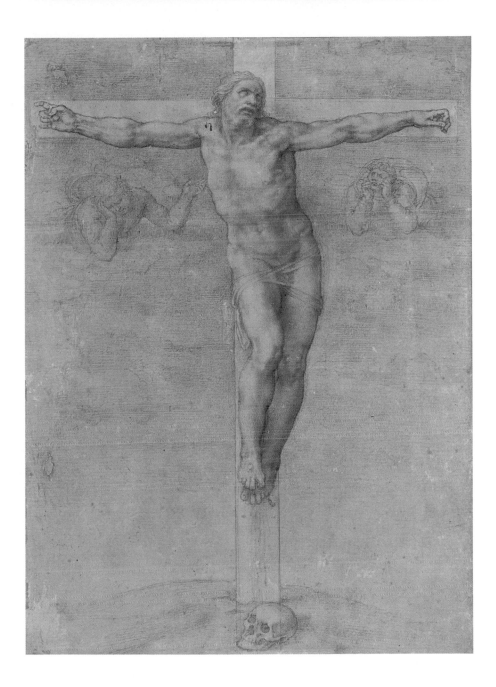

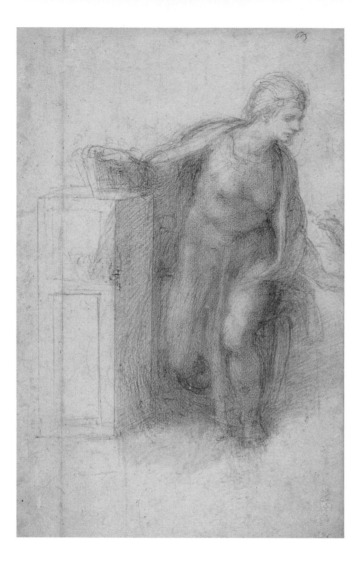

52
The Virgin Annunciate, *c.* 1545–7.
Black chalk, 34.8 × 22.4 cm.

opposite
53
The Annunciation, *c.* 1545–7.
Black chalk, 28.3 × 19.6 cm.

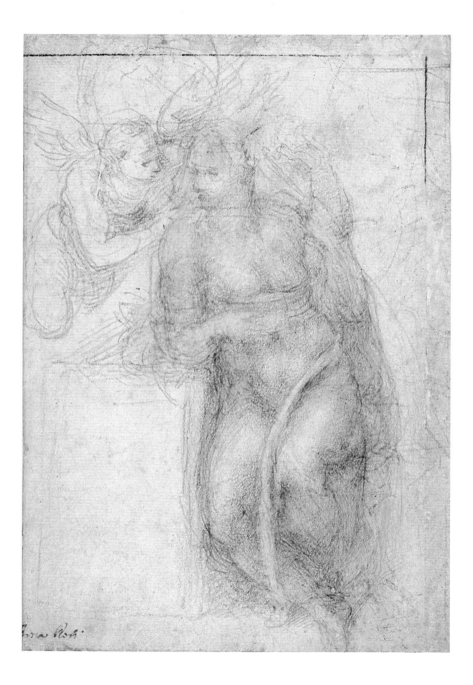

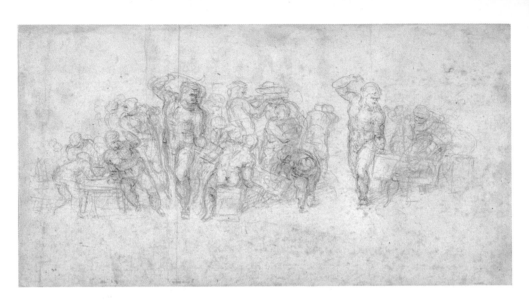

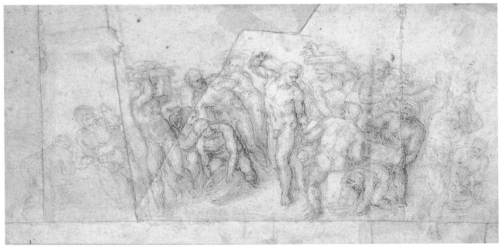

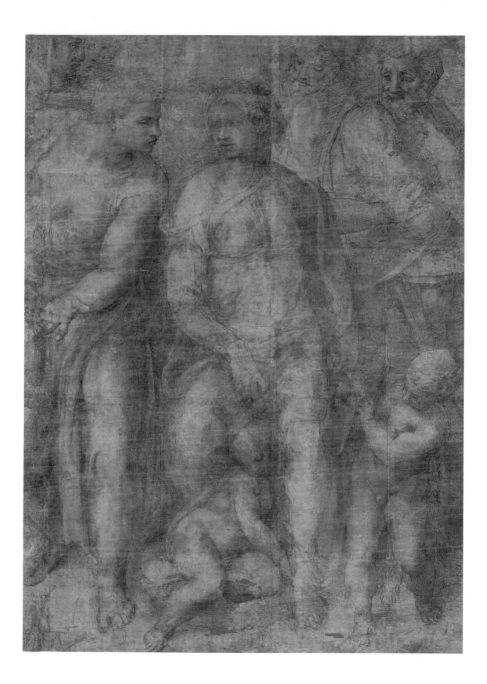

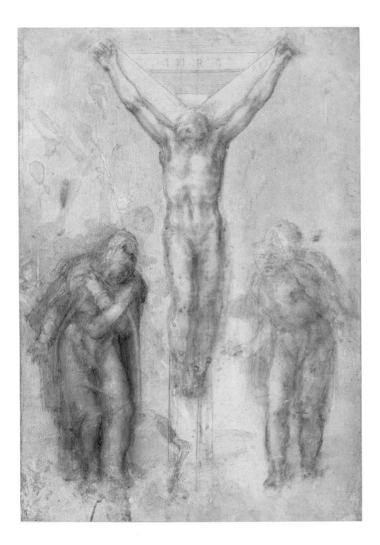

57
**The Crucifixion with the Virgin
and St John**, *c.* 1555–64. Black
chalk, heightened with lead white
(discoloured), 41.3 × 28.6 cm.

opposite
58
**The Crucifixion with the Virgin
and St John**, *c.* 1555–64. Black
chalk, heightened with lead white
(discoloured), 41.2 × 27.9 cm.

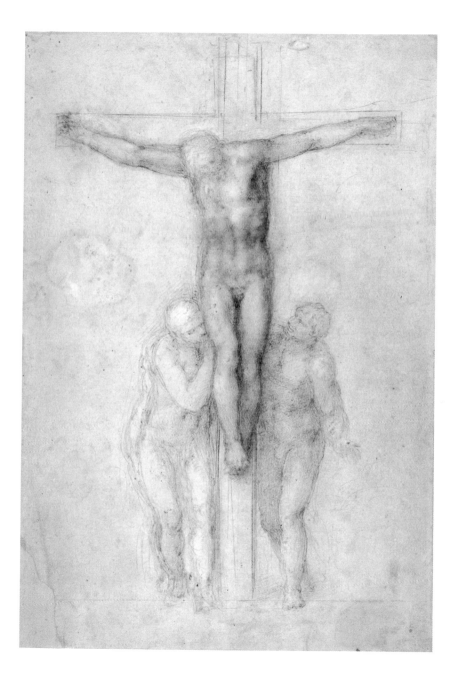

Further Reading

The following list is intended as a guide to recommended books with the emphasis on those written or available in English, and still to be found in bookshops – new and second hand – or in good art libraries. Space does not allow mention of any articles on varying aspects of Michelangelo's work and career published in specialist journals, but references to these can be found in the bibliographies of many of the books cited here.

Michelangelo's poetry and letters

Linscott, R.N. (ed.) (1980) *Complete Poems and Selected Letters of Michelangelo*, trans. C. Gilbert, Princeton.

Ramsden, E.H. (1963) *The Letters of Michelangelo, Translated from the Original Tuscan, Edited and Annotated*, 2 vols, London.

Ryan, C. (ed.) (1996) *Michelangelo, the Poems*, London.

Saslow, J.M. (1991) *The Poetry of Michelangelo*, New Haven and London.

Contemporary accounts of Michelangelo

Armenini, G.B. (1988) *De'Veri Precetti della Pittura*, ed. M. Gorreri, Turin.

Condivi, A. (1999) *The Life of Michelangelo*, trans. A.S. Wohl, ed. H. Wohl, Pennsylvania.

Hollanda, F. de (1998) *Diálogos em Roma (1538): Conversations on art with Michelangelo Buonarroti*, ed. G.D. Folliero-Metz, Heidelberg.

Vasari, G. (1996) *Lives of the Artists*, trans. G. du C. de Vere with introduction and notes by D. Ekserdjian, 2 vols, London.

General studies

Bull, G. (1995) *Michelangelo, a Biography*, New York.

Hatfield, R. (2002) *The Wealth of Michelangelo*, Rome.

Hibbard, H. (1985) *Michael Angelo*, 2nd edn, Harmondsworth.

Hughes, A. (1997) *Michelangelo*, London.

Murray, L. (1984) *Michelangelo: His life, work and times*, London.

Summers, D. (1981) *Michelangelo and the Language of Art*, Princeton.

Michelangelo's art and architecture

Ackermann, J.S. (1986) *The Architecture of Michelangelo*, 2nd edn, Harmondsworth.

Argan G.C. and B. Contardi (2004) *Michelangelo Architect*, English language edn, Milan.

Baldini, U. (1982) *The Complete Sculpture of Michelangelo*, London, 1982.

Barnes, B. (1998) *Michelangelo's 'Last Judgement', the Renaissance Response*, Berkeley, Los Angeles and London.

Hartt, F. (1969) *Michelangelo, the Complete Sculptures*, London.

Hirst, M. and J. Dunkerton (1994) *Making and Meaning: The young Michelangelo*, exh. cat., National Gallery, London.

Mancinelli, F. (ed.) (1994) *Michelangelo, the Sistine Chapel: The restoration of the ceiling frescoes*, 2 vols, Treviso.

Nagel, A. (2000) *Michelangelo and the Reform of Art*, Cambridge.

Poeschke, J. (1996) *Michelangelo and his World*, trans. R. Stockman, New York.

Pope-Hennessy, J. (1996) *Italian High Renaissance and Baroque Sculpture*, 4th edn, London.

Wallace, W.E. (1994) *Michelangelo at San Lorenzo: The genius as entrepreneur*, Cambridge.

Wilde, J. (1978) *Michelangelo: Six lectures*, Oxford.

Michelangelo drawings

Berenson, B. (1970) *The Drawings of the Florentine Painters*, reprint of 1938 edn, 3 vols, Chicago and London.

Chapman, H. (2005) *Michelangelo Drawings: Closer to the Master*, exh. cat., Haarlem, Teyler Museum and British Museum, London.

Hirst, M. (1988a) *Michelangelo and his Drawings*, New York and London.

Hirst, M. (1988b) *Michelangelo Draftsman*, exh. cat., National Gallery of Art, Washington.

Joannides (1996) *Michelangelo and his Influence: Drawings from Windsor Castle*, exh. cat., National Gallery of Art, Washington, and Kimbell Art Museum, Fort Worth.

Tolnay, C. de (1975–80) *Corpus dei disegni di Michelangelo*, 4 vols, Novara.

Wilde, J. (1953) *Italian Drawings in the Department of Prints and Drawings in the British Museum: Michelangelo and his studio*, 2 vols, London.

Illustration References

All photographs © The Trustees of the British Museum, Department of Prints and Drawings, courtesy of the Department of Photography and Imaging. The recto and verso of each drawing is indicated when both sides are illustrated; otherwise all works illustrated are rectos.

All the works in this publication were included in the exhibition *Michelangelo Drawings: Closer to the Master* held at the British Museum from 23 March to 25 June 2006.

Fig.	Exh. No.	BM Reg. No.
Frontispiece	1	1868-8-22-63
1	5 Recto	1895-9-15-498r
2	5 Verso	1895-9-15-498v
3	11	1887-5-2-116
4	13 Recto	1887-5-2-117r
5	13 Verso	1887-5-2-117v
6	15	1895-9-15-496
7	7	1895-9-15-495
8	14 Recto	1859-6-25-564r
9	14 Verso	1859-6-25-564v
10	17	1859-6-25-567
11	18 Recto	1859-6-25-568r
12	18 Verso	1859-6-25-568v
13	19	1887-5-2-118
14	25 Recto	1926-10-9-1r
15	25 Verso	1926-10-9-1v
16	29	1895-9-15-497
17	32	1895-9-15-500
18	33	1895-9-15-813
19	34	1860-7-14-2
20	35	1860-7-14-1
21	40 Recto	1859-5-14-822r
22	40 Verso	1859-5-14-822v
23	41	1859-5-14-823
24	43	1859-6-25-544
25	58 Recto	1859-6-25-550r
26	58 Verso	1859-6-25-550v
27	59	1859-5-14-818
28	61	1859-6-25-561
29	63	1859-6-25-557
30	64 Recto	1859-6-25-547r
31	64 Verso	1859-6-25-547v
32	66 Recto	1895-9-15-493r
33	66 Verso	1895-9-15-493v
34	70	1895-9-15-519
35	71	1860-6-16-3
36	76	1895-9-15-501
37	77	1887-5-2-119
38	78	1860-6-16-133
39	79	1860-6-16-1
40	80	Pp1–58
41	81	1895-9-15-517
42	82 Recto	1895-9-15-518r
43	82 Verso	1895-9-15-518v
44	83 Recto	1980-10-11-46r
45	83 Verso	1980-10-11-46v
46	85	1860-6-16-5
47	86 Recto	1886-5-13-5r
48	86 Verso	1886-5-13-5v
49	88	1947-4-12-161
50	90	1896-7-10-1
51	91	1895-9-15-504
52	93	1900-6-11-1
53	94	1895-9-15-516
54	97	1860-6-16-2/2
55	99	1860-6-16-2/3
56	95	1895-9-15-518*
57	106	1895-9-15-509
58	107	1895-9-15-510